ISBN 1
8566
91 640

Contemporary
Music Graphics

Written and designed by Intro

W9-BFJ-531

First Published in the United States of America in 1999
by **UNIVERSE PUBLISHING**
A Division of Rizzoli International Publications, Inc.
300 Park Avenue South
New York, NY 10010

Copyright © text & design 1999 Intro

99 00 01 02 10 9 8 7 6 5 4 3 2 1

Library of Congress Catalog Card Number: 99-17538

ISBN 0-7893-0258-6

Printed in Hong Kong

Nobody ever bought a record because they liked the cover

... art begins where information ends
Peter Kemper, *Sleeves of Desire*

In the film *Nil by Mouth* – Gary Oldman's bleak portrayal of a chronically dysfunctional London family – one of the characters describes a visit to an orgy: 'So I strip down to me boxers, right? Sit down on the settee, and start... get an album cover... and start rollin' up a joint.' This use of the album cover as a portable work surface for drug culture dates the action to the pre-CD era: a time when album covers were revered as 'emblems of generational identity'[1], and widely regarded by graphic designers – and more importantly, the record buying public – as one of the principal arenas for artistic expression and visual experimentation.

Since the mid-fifties the album cover has provided a unique outlet for radical visual expression, and sleeve designers have enjoyed an authorial freedom rarely attained by designers and artists working in areas of commercial importance comparable to the record industry. But over the past decade the notion of the album-cover-as-art has come under threat. Sleeve design, in its fight to remain a worthwhile occupation for contemporary designers, artists and photographers, has had to contend with a number of potentially fatal body blows.

The first of these thunderbolts was the arrival in the mid-eighties of the compact disc. Almost overnight, the little silver disc consigned the big black vinyl disc to the bins of charity shops, to car boot sales and to the obsessive attentions of the record collectors' market. And although dance music and the cult of the DJ has ensured that vinyl records have not completely vanished, the abandonment of the LP by mainstream record companies has resulted in a generation of sleeve designers forced to adapt to the reduced canvas of the CD: where once the generous proportions of the 12-inch vinyl record sleeve provided ample space for subtlety and invention, the flimsy CD booklet, wedged inside an unyielding 'jewel case', encourages little beyond utilitarian design.

The dominance of the CD as the principal carrier for recorded music is not the only threat to sleeve art. A new brutalism has entered the global record industry; a fierce drive for sales-at-any-price has resulted in the gradual demotion of sleeve design – at least within the big record companies. Previously regarded as an essential and integral part of a successful record, there is now a tendency to treat sleeves as merely another marketing surface to be covered with price stickers and the buy-me-now graphics of modern consumerism. The notion that the design of the cover might act as a sympathetic visual accompaniment to the musical content of a record – what the visionary English sleeve designer Vaughan Oliver has defined as 'the successful reflection of the music... creating a third entity that is greater than its individual parts'[2] – is increasingly irrelevant to most modern mainstream record companies.

Amongst graphic designers – especially young designers and design students – the record industry is often regarded as a creative free-fall zone; designer-do-what-thou-wilt. Nowadays the opposite is frequently the case. Compared with other areas of graphic design – food packaging and financial reporting, for instance – design for the record industry remains an area of licence and relative freedom. But in today's record business sleeve design is governed by marketing considerations, and at a time when the industry finds itself locked in a war with computer games, fashion, books and other areas of consumer spending, these considerations are becoming increasingly restrictive.

In the current climate, for instance, it is almost unthinkable that any mainstream record company would willingly commission a cover to rival the complexity and visual sophistication of The Beatles' *Sergeant Pepper's Lonely Hearts Club Band* (Parlophone, 1967). The designers Peter Blake and Jann Haworth (and photographer Michael Cooper) ignore too many current record industry marketing nostrums. The list of rules they break is lengthy. Nowadays titles of albums are preferred at the top of sleeves rather than at the bottom (to be certain of winning the approval of record company sales and marketing departments, titles should be placed in the top left-hand corner of

sleeves thus allowing retailers to place price stickers in the right-hand corner). Blake and Haworth would also find that glamorous portraiture is generally preferred to graphic abstraction or visual experimentation. And perhaps most tellingly of all, *Sergeant Pepper's* complex, detail-rich tableau with its clever depiction of the artists', and the Beatles' varied enthusiasms, would be thought unsuitable for the shrunken canvas of CD packaging.

It is also likely that in the current climate – a time when budgets are being savagely cut throughout the record industry – Blake and Haworth's vision would fall foul of the accountant's estimation of what sleeve design should cost: the 12-inch gatefold format of *Sergeant Pepper* would cause apoplexy in the cost control departments of the big labels.

Other restrictions facing the contemporary sleeve designer are more insidious. Vaughan Oliver – a shrewd observer of the record industry – has pointed out that 'Huge budgets are lavished on music videos and consequently sleeve design budgets suffer, which is odd because album covers sometimes hang about for twenty years whereas videos often have a shelf life of only a few weeks.'[3]

Even the record retailers exert a powerful and direct influence on packaging and design trends. British and European retailers habitually resist alternatives to the ubiquitous CD jewel case, and despite the existence of numerous viable packaging options, record companies are reluctant to experiment for fear of antagonizing the powerful retail buyers. In America the situation is even worse: the inside of CD booklets are often printed in a single colour, and 4-page booklets are the norm.

But the irony of this new commercial brutalism is that it is being enacted at a time when record sales are depressed, and when the record business is enduring one of its periodic recessions. In the week that these words were being written, the NME – the more radical of the two music weeklies published in the UK – devoted six pages to chronicling the dramatic decline of the record industry. Titled 'The Great Rock and Roll Dwindle', the article took

the form of a lengthy catalogue of collapsing record sales and increasingly frenetic behaviour on the part of the record companies. It described how the record business, having drained the vast reservoirs of its back catalogues (everyone has by now replaced their old scratchy vinyl discs with new shiny silver ones), is now attempting to ensure its future by increasingly desperate measures. With the NME's customary use of the language of sophisticated critical appraisal, the record industry is described as 'fucked'.

The article also contains an essay written by Alan McGee, founder of Creation Records, which bolsters the NME's account of terminal decline within the record industry. For many, McGee represents the acceptable face of the modern record business. Undeniably successful, he runs Creation, home of, amongst others, Oasis and Primal Scream, with a refreshing honesty and vigour. A profound love of music forms the core of McGee's approach to running a record company – an increasingly rare phenomenon in the modern record business. As he notes in his essay, the problems facing the industry are easily identified, 'It's no wonder people aren't buying records! There's nothing to get excited about at the moment. When I ask people what they think of the music scene, they say it's a dilution of a dilution of a dilution. The other criticism is that music doesn't have an ideological point of view any more so it's not central to people's existence... '

More sober publications than the NME take a similar view. The business pages of the daily newspapers regularly carry reports of the collapsing share prices of the big labels. Financial journalists, their columns untypically decorated with pictures of brooding pop stars rather than portly captains of industry, describe the predatory actions of giant corporations bidding to acquire beleaguered record companies on the cheap. Other articles contain lurid predictions of the imminent demise of the traditional record industry due to the threat posed by the digital distribution of music via the Internet. The overriding impression is of the large record companies preparing for a fight for survival.

There is an alternative explanation for the cause of the problems facing the record industry. Put simply, the record companies have become divorced from their roots; they can be said to have lost touch with the reasons *why* people buy records. Where labels were once run by idealistic music lovers who had usually played in bands – or were at least fuelled by the glamour of the music business – they are now run by business professionals with little or no interest in music, deploying sales techniques more suited to household cleaning products. Today labels demand instant success from new acts; bands are signed for huge advances and then, if their first record fails to climb the charts, they are dropped from the label's roster of signed artists.

The recently deposed chairman of one of the giant conglomerates which control the modern record business admitted that he had pushed his artists and his staff too hard, forcing them to release records before they were ready and suffering poor sales as a consequence. If the record industry is to survive it must realize that most people – other than the very young – buy records because they are emotionally or artistically engaged by them and the sleeve plays an important part in formulating this response. Music fans, perhaps uniquely amongst consumers, expect innovative packaging; they look for, and relish, visual innovation, style and sheer bloody weirdness. The record companies ignore this at their peril.

So, as the record business enters a period of turmoil and uncertainty, what hope is there of the poor record cover remaining a vital platform for radical visual expression? At first glance the likelihood looks remote, but this book is an attempt to show that it does have a future, and as always during periods of uncertainty in the record business, the future is in the hands of maverick labels, musicians and designers on the peripheries of the mainstream. This book is a celebration of their attempts to keep innovation alive within sleeve design, and in doing so, to show the way ahead for visual communication: today's weirdo record cover is tomorrow's mass-market advertising campaign.

But first a glance in the rear-view mirror...

The 33 year old Englishman, Tim Wilson, has the ability to read records. When, for example, the complete recorded symphonies of Beethoven were shown to him, he could identify in detail the un-labelled records. Taken from *Broken Music (Artists' Recordworks)*

As Philip Larkin memorably pointed out, a number of cultural changes coincided with the release of The Beatles' first LP. But the cult of the album cover was not one of them. Nor can it be said to have begun with their second LP, *With The Beatles* (Parlophone, 1963), despite Robert Freeman's influential black and white cover photograph; nor with his subtly attenuated cover shot for *Rubber Soul* (Parlophone, 1965), which hinted at the psychedelic revolution that was about to immerse the Beatles and most of the Western world.[4] Instead it was *Sergeant Pepper*, released at the apogee of the group's career, that created the notion of the-album-cover-as-art. Of course, memorable record covers existed prior to the release of The Beatles' masterwork, but it took their unprecedented popularity to alert the whole world to the potential of this new art form.

Up until the release of *Sergeant Pepper*, the commissioning of sleeve design was a function of the publicity departments of record companies. The greatest single contribution made by Blake and Haworth's cover was that The Beatles commissioned it themselves (on the advice of art dealer Robert Fraser). This sent a signal to other sixties groups – most of whom scrutinized every move The Beatles made – that ensuring a successful sleeve design was as important as any other aspect of the recording process, and its execution should not be left to an uncaring record company.

For many people the cover of *Sergeant Pepper* was their first exposure to contemporary art. Blake, and his then wife Haworth, were established artists; Blake was the UK's leading Pop artist and Haworth had a reputation 'at the periphery of mainstream Pop'.[5] Before *Sergeant Pepper* it is doubtful if any beyond a tiny coterie of art lovers were familiar with their work. Yet with the release of *Sergeant Pepper*, contemporary art secured a foothold at the very centre of everyday life. It was to be seen

Artist: Happy Mondays
Title: *Bummed*
Design: Central Station
Label: Factory

Artist: Joy Division
Title: *Unknown Pleasures*
Design: Peter Saville
Label: Factory

Artist: New Order
Title: *Power, Corruption and Lies*
Design: Peter Saville
Label: Factory

Artist: Various
Title: *The Factory Sampler*
Design: Peter Saville
Label: Factory

Artist: Durutti Column
Title: *The Catalogue*
Design: 8VO
Label: Factory

Tony Wilson
Factory

everywhere: on sale in high-street shops; occupying a cherished place in the bedrooms of thousands of teenagers; and carried about totemistically, under the arms of students, as a cultural badge of hipness.

Blake was not the first important figure from the visual arts to have an interest in designing record sleeves. The symbiotic relationship between sound and vision attracted visual artists from the start of recorded music and many artists and designers had already used the 12-inch record sleeve as a landscape for visual expression. The German artist and photographer Josef Albers designed the covers for two percussion records in 1959, and the Beat artist Wallace Berman had designed jazz sleeves as early as 1947.[6]

In Europe, Josef Beuys and Marcel Duchamp created covers – often individually numbered and handmade – for the experimental sound recordings they themselves made, or participated in.[7] These limited edition works of art hardly qualify as commercial releases, but they stand as intriguing examples of sleeve design, and are remarkably similar to some of the more experimental limited-edition releases emanating from the current generation of underground and radical music labels. The spirit of Beuys and Duchamp lives on in the work of artist/designer Russell Mills whose densely textured covers for a wide range of intelligent musicians are amongst the most evocative in the cannon of sleeve design (see pages 134–137).

The great American modern artist Robert Rauschenberg's sleeve for Talking Heads' *Speaking in Tongues* (Warner Bros., 1983) is a genuine commercial release, and bears an astonishing stylistic resemblance to the more outré trends in current record sleeve design. It contains a vinyl disc in a see-through plastic wallet with three movable foils on to which are printed collages made by the artist. The American conceptualist Lawrence Weiner has created striking packaging for his own sound recordings. His sleeve design for his 1993 release *Ships at Sea, Sailors & Shoes* (Triple Earth, see page 98) hints at why he has become the inspiration for a small band of important English sleeve designers, attracted to his considered use

of letter forms. His influence can be seen on a number of contemporary record covers.

The rise of record packaging in the mid-fifties coincided with the powerful undercurrents unleashed by the new era of mass media. Many artists became infatuated with the imagery of advertising and mass-communications and looked for ways to incorporate this inchoate visual language into their work: it was an interest that was to culminate in the establishment of Pop Art. No one embraced the new visual culture with more relish than Andy Warhol: in pop sleeves he found a canvas on which to explore his interest in the recycling and replication of the iconography of consumerism. Although he had designed jazz album covers in the fifties (revealing the pronounced influence of jazz sleeve designer David Stone Martin) it was the mass-produced pop album – endlessly replicated around the world just like his beloved soup tins – that inspired Warhol to some of his most interesting work.

The Beatles maintained their tradition of patronizing the elite of British Pop Art by commissioning Richard Hamilton to design the follow up to *Sergeant Pepper*. Called simply *The Beatles* (Parlophone, 1968) Hamilton's famous all-over-white cover with its wilful disregard for the conventions of the record sleeve established Hamilton as an even more radical figure than Blake, and helped create the template for future sleeve designers as renegade figures within the graphic design tradition, above the prosaic considerations of commercial necessity. Hamilton's austere cover was to find an echo in the eighties when a later generation of sleeve designers, led by Peter Saville and Mark Farrow, embraced minimalism.

The custom of inspired patronage started by The Beatles was maintained by their arch rivals The Rolling Stones, who commissioned the Swiss/American photographer Robert Frank to design the cover of their album *Exile on Main Street* (Rolling Stones Records, 1972). Credited with 'photography and concept'[8] Frank produced a cover that transcended pop culture and is clearly the work of a visionary artist. (He later made a full-length film for the

Artist: Kraftwerk
Title: *Trans-Europe Express*
Design: Ink Studios, Düsseldorf
Maurice Seymour, New York
Label: Capitol

Artist: The Mothers of Invention
Title: *Weasels Ripped My Flesh*
Design: Neon Park
Label: RYKO

Artist: Gang of Four
Title: *Entertainment!*
Design: Jonking, Andy Gill
Label: EMI

Artist: Karlheinz Stockhausen
Title: *Greatest Hits*
Label: Polydor

Artist: Negativ Land
Title: *Escape From Noise*
Design: Francesca Freedman
Label: SSI

Chris Hendrie
Product Manager
Island Records

Stones called *Cocksucker Blues*, and subsequently music videos for New Order and Patti Smith.) The importance of Frank's contribution to the evolution of sleeve design is incalculable. His melancholic influence can be seen today in the videos and sleeves of REM and in the work of a number of important photographers active in music today. His depiction of a visionary America has been widely appropriated by the makers of youth advertising.

Many of the leading figures of twentieth-century graphic design have been seduced by the double-sided 12-inch cardboard square. Saul Bass, an undeniably major figure in the graphic design firmament, created numerous LP covers in the fifties, usually for the soundtrack albums of the films to which he had contributed his memorable title sequences.[9] Early practitioners of the art of sleeve design were Alvin Lustig and Alex Steinweiss, both substantial figures in post-war graphic design. Their predominantly abstract covers for early American classical records have an emotional range unthinkable in the classical sleeves of today and are remarkably similar to current notions of sleeve design, especially in techno and electronic music. Milton Glaser, a graphic design luminary from a later era, famous for his robust versatility, designed numerous album covers. Even Norman Rockwell, the personification of American folksiness – his style has been much lampooned on album covers – attempted sleeve design. His illustration for the Mike Bloomfield and Al Kooper album, *The Live Adventures of...* (CBS, 1969) suggests that he will remain best remembered for his *Saturday Evening Post* covers, rather than for his contribution to sleeve art.

In recent years the trend for fine artists to dabble in sleeve design has continued. It is perhaps unsurprising that the controversial English artist Damien Hirst has found the album cover a suitable outlet for his brand of visual bourgeois terrorism. (Ironically, Hirst has become the Norman Rockwell of the 1990s, due to his unashamedly populist involvement in football-inspired pop songs, and the attraction he exerts over the tabloid-reading sections of British society.) His sleeve for Dave Stewart's album

Greetings from the Gutter (Anxious, 1994) is stylistically indistinguishable from the more consciously arty sleeves of many of the current generation of sleeve designers.

Although it can be demonstrated that the record cover has exerted a strong attraction on visual artists and important figures from the world of graphic design, the development of sleeve design has, from the very beginning, been in the hands of commercial graphic designers. And what is significant about the best of these individuals is that they have produced expressive and visually sophisticated work at the very heart of commercial culture. Their work is on show daily in the shopping malls and temples of consumerism throughout the modern world. And it is these designers – often solely engaged in sleeve design, and therefore excluded from orthodox graphic design circles – who have made the iconography of the record cover into a universally recognized visual language which has penetrated the collective imagination in a way no other field of graphic design – and indeed few areas of the visual arts – can be said to have done.

The list of designers who have contributed to this process is lengthy. Some have made lasting reputations, most have appeared meteor-like only to disappear without a trace, and only one or two have survived the era of their fame. But it is worth examining the contribution of some particularly important figures whose achievements have led to recognition – if perhaps fleetingly. Talented individuals who have influenced the way visual culture has developed and whose work has stimulated an interest in the subject of visual communication itself; people who, it is not going too far to say, have influenced the way we comprehend, assimilate and enjoy the torrents of visual material that surround our daily lives.

Artist: AMM
Title: *AMM Music*
Label: Elektra

Artist: Kraftwerk
Title: *Kraftwerk 1*
Design: Ralf Hutter
Label: Phillips

Artist: Archie Shepp
Title: *The Magic of Ju-Ju*
Design: Robert &
Barbara Flynn/Viceroy
Label: Impulse

Artist: Harmonia
Title: *Music Von Harmonia*
Design: Harmonia
Label: Brain

Artist: Serge Gainsbourg
Title: *Histoire De Melody Nelson*
Photography: Tony Frank
Label: Polydor

Tim Gane
'Sound tinkerer of melody loops'
Stereolab

... it is getting a bit silly when the sleeve is more important than the record.
Jon Savage, 'The Age of Plunder' *Time Travel*

In 1948, when the long-play vinyl record was first introduced, the American record industry was already established as a powerful and lucrative business, and by the mid-fifties the notion of a record cover as more than a 'protective over-coat' for discs was well advanced. The cover for Frank Sinatra's *In the Wee Small Hours of the Morning* (Capitol, 1955), for example, exhibited a cool noir-ish poise that was to help propel sleeve design beyond its prosaic origins. It was a sleeve that owed a great stylistic debt to cinema poster art, and was to be mimicked throughout the next thirty years, finding echoes in the sleeves of later generations of pop stars seeking to emulate Sinatra's ineffable coolness.

The anodyne graphics and photography of American fifties and early sixties pop sleeves sought to reflect the burgeoning teenage culture. But they revealed little beyond the commercial imperatives of a business that sensed it had acquired a product irresistible to the first generation of affluent teenagers. To contemporary eyes these sleeves appear kitsch and exploitative, yet undeniably coated with a patina of nostalgic charm: 'the transient endures' as the writer Rob Chapman notes in the book *Vinyl Junkyard*. At the same time, the first generation of hi-fi owners, with middle-of-the-road musical tastes, was catered for by sleeves that manifested the aesthetics of the dime-store: flowers, pretty girls and musical instruments photographed with starburst filters. But there was an alternative to bubblegum iconography and chocolate-box schmaltz – jazz.

The Scottish Beat writer Alexander Trocchi called jazz 'America's greatest contribution to culture'.[10] Jazz record covers offered intelligence, style, visual wit and a genuine graphic reflection of the music. In 1956 Reid Miles, a graphic designer formerly on the staff of *Esquire* magazine, became the in-house designer for the celebrated New York jazz label, Blue Note. Working in tandem with

photographer Francis Wolff, they became one of the most successful and enduring sleeve design partnerships. Intriguingly, Miles was not even a jazz enthusiast and relied on verbal descriptions of the music for inspiration. Blue Note sleeves have become universally recognized as visual shorthand for hipness and coolness, and they have been plundered mercilessly by a generation of designers keen to appropriate the unmatchable cool of Wolff and Miles' covers.

Reid Miles' claim to a place amongst the best sleeve designers is unassailable. Indeed, his Blue Note work constitutes one of the most substantial statements in modern graphic design. Anyone who doubts this should look closely at two famous Blue Note sleeves: Grachan Moncur III's *Some Other Stuff* (1964), and Eric Dolphy's *Out to Lunch* (1964). For both these sleeves Miles provided photography and design; judged by any criteria, they are powerful and resonant visual statements.

Over on the West Coast, an alternative version of jazz style was evolving. Lacking the robustness of Blue Note's New York street stance, the breezy graphics of the Californian labels - frequently the work of photographer William Caxton and designer Bob Guidi – depicted the 'cool jazz world of cocktails, sports slacks, and continental coupes'[11]. It took the establishment of the Impulse label in 1960, also based in New York, to offer a stylistic pose worthy of comparison with Blue Note. Less varied than Reid Miles' label, Impulse pursued a taut line of visual expression which perfectly mirrored the hard edge of the musicians then recording for the company: John Coltrane, Archie Shepp, Horace Silver and numerous other jazz luminaries. Impulse sleeves – the best designs invariably credited to Robert Flynn/Viceroy – utilized powerful modernist typography with an economy of expression that is impervious to design fashion.

By comparison the graphics and apocalyptic visual style that emerged from the hippie movement in the early to mid-sixties, initially centered around San Francisco, appears to contemporary eyes quaint and dandified.

Chaotic and serpentine imagery crawled over album covers and posters in an attempt to replicate the hallucinatory experience of psychedelic drugs. The utopian lifestyle of the hippie counter-culture had a cataclysmic effect on Western society, forcing a myriad of changes on a generation, and not the least of these was the formation of a new visual language: unreadable typography, hidden messages, acidic colours. These elements combined to act as a deterrent to the straight world; *if you can't read this it's not for you, anyway*. Psychedelic art was first and foremost a code, decipherable only by the initiated, and forming a cultural barrier for older generations. This was a process that was to be repeated within youth culture, over and over again for the next 30 years. It can be seen in the record covers and stylistic poses of punk (itself a violent reaction against middle-class hippie ideals), rave (ironically a readoption of psychedelic imagery and hippie hedonism) and rap (the assertion of black street culture).

A few genuinely inspirational artists did emerge from the San Francisco scene; the most celebrated examples being Stanley Mouse and Rick Griffin. Both became intimately associated with the leading psychedelic groups of the period, principally The Grateful Dead. But the psychedelic era will probably best be remembered for its posters, rather than its album covers. In England the psychedelic flag was waved by Dutch hippie artists The Fool. According to George Martin, in his book, *With a Little Help from my Friends* (Little, Brown, 1994), they produced a sleeve design for *Sergeant Pepper* prior to the commissioning of Blake and Haworth. Their sleeve design for proto-hippies The Incredible String Band's *5000 Spirits* (Elektra, 1967) has an authentic air of high-psychedelia, but perhaps their greatest claim to fame was the Day-Glo mural they painted on to the outside of The Beatles Apple HQ in London.

In England the pre-eminence of the Haight Ashbury poster artists was briefly rivalled by an artistic duo called Hapsash and the Coloured Coat. More whimsical than their US counterparts, Nigel Waymouth and Michael English's work was infused with the benign spirit of Lewis Carroll, J.R.R.Tolkien and the English Faerie tradition.

Although not sleeve designers, they created a counter-culture growth industry in posters, which exerted a strong influence on the sleeve designers of the time. They did, however, design the cover for an album of their own music: *Hapsash and the Coloured Coat featuring the Human Host and the Heavy Metal Kids* (Liberty, 1967).[12]

Both The Fool and Hapsash were overshadowed by the Australian artist/designer Martin Sharp. His cover for Cream's *Disraeli Gears* (Polydor, 1967) stands as a powerful visual testament to unrestrained psychedelic extravagance. He was also responsible for much of the 'visual extremism'[13] of *Oz* magazine, a publication that was to help launch the career of Barney Bubbles, a key figure from the next generation of sleeve designers.

Elsewhere there were signs of a new movement in sleeve design. In the same year that The Beatles commissioned *Sergeant Pepper*, Andy Warhol's cover for *The Velvet Underground and Nico* (Verve, 1967) offered stark alternatives to the US hippie obsessions with Edwardiana, Art Nouveau and the mystical East. Warhol was strongly attracted to the New York proto-heroin-chic of The Velvet Underground, and his banana cover with its arch instruction to *peel slowly and see*, is perhaps the first truly modernist pop album cover. In the following year, William S. Harvey and Joel Brodsky's cover for The Doors' *Strange Days* (Elektra, 1968) is again a design statement at once more modern and less indulgent than sleeves produced at this time. Taken together these covers mark an approach to sleeve design that would lead away from the sprawling indulgence of psychedelia and the endless repetition of pop culture iconography, towards something closer to modern graphic design.

At the end of the sixties the record industry entered a phase of rapid transformation. It became in Jon Savage's phrase, 'the rock industry'[14] and in America at least, acquired a hard edge brought about, largely, by the arrival of a new breed of young moguls, whose lifestyles were often indistinguishable from the groups they signed to their labels. They propelled the record business to

Artist: The Beatles
Title: *The Beatles*
Design: Robert Brownjohn
Label: Parlophone

Artist: Can
Title: *Ege Bamyasi*
Design: Ingo Traver,
Richard D. Rudow
Label: Spoon

Artist: Janes Addiction
Title: *Ritual De Lo Habitual*
Design: Perry, Casey &
Tom Recchiou
Label: Warner Bros

Artist: The Mothers of Invention
Title: *Weasels Ripped My Flesh*
Design: Neon Park
Label: RYKO

Artist: Wire
Title: *Pink Flag*
Design: B.C. Gilbert & Lewis
Label: EMI

Cally Calloman
Designer
Antar

unimaginable heights of wealth and success. Sleeve design was dragged along in the wake of this hurricane and was to undergo its own process of transformation. The innate folksiness and whimsicality of much sixties music had been abandoned by a new generation of rock stars and the sleeves of the period reflected this change. Budgets were vast, the bands – behaving like Renaissance princes – demanded ever more lavish sleeves, and the record companies, gorged on the proceeds of multi-platinum album sales, indulged them willingly.

The progressive rock groups of the early part of the seventies lifted the art of sleeve design to often laughable heights. Just as the music became associated with bombast, hobgoblin mythology and the rock-and-roll lifestyle (a Spinal Tap life of drugs, pre-Aids sexual licence, and tawdry stardom) so too did the covers. The defining sleeves of this period were undoubtedly those of Roger Dean. For many, Dean came to define the territory; his quasi-mythical landscapes, clearly inspired by the English fairy story illustrators Dulac and Rackham, conferred a badge of progressive musical credibility much sought after by the leading groups of the period. Terminally linked with the archetypal seventies band Yes, his sleeve for their *Tales From Topographic Oceans* (Atlantic, 1973) captures the era more pungently than a pair of loon pants and a cheap joss stick.

Dean's reign as the leading sleeve designer was short-lived, although a variation of his school of illustration lived on with the rise of heavy metal and the cult of Sword and Sorcery. He was eventually eclipsed by Hipgnosis, the new stars of seventies sleeve design. Founded by Aubrey 'Po' Powell and Storm Thorgerson, they designed the first of many covers for the Pink Floyd as early as 1968: *A Saucerful of Secrets* (EMI) exudes a more robust and mature expression of the English hippie aesthetic than was commonly to be found on album covers of the time. But it was their 1970 cover for a later Pink Floyd album, *Meddle* (EMI), which first revealed the sophistication they brought to their best work. The *Meddle* cover (featuring a banal photograph of a Friesian cow in a field) exudes a

powerful visual intelligence: an intelligence far removed from the hippie indulgence of the previous decade, and drawing on artistic modes of expression from beyond graphic design – principally surrealism.

Hipgnosis worked for the rock aristocracy (most memorably Pink Floyd and Led Zeppelin). They provided a welcome antidote to the whimsy and infantilism of the average prog-rock cover, and their popularity grew enormously. Their best work was infused with an instinctive surrealism and an attention to the craft skills of graphic design: typography, illustration, photography, retouching, repro and print technology. Prior to Hipgnosis, sleeve design had generally been undertaken by designers relying on raw intuition with little regard for graphic refinement; an anything goes philosophy of hand lettering, jolly pastiche and free expression. But Hipgnosis changed this. They made frequent use of the best craft skills available to them and collaborated with many of the leading English figures in graphic design. Their work with George Hardie, who gave typographic sophistication to many of their covers – most noticeably Pink Floyd's *Dark Side of the Moon* (EMI, 1973) and Led Zeppelin's *Presence* (Swan Song, 1976) – is perhaps the best example of this.

Viewed today, the refinement Hipgnosis brought to their covers stands as perhaps their most lasting contribution to the history of sleeve design. They brought, for the first time, the production standards of advertising into the music industry and yet retained the guerilla aesthetics of earlier pioneers of cover art. Their sleeve for The Strawbs' *Deadlines* (Arista, 1978) demonstrates this brilliantly. The gatefold sleeve shows a man floating upside down in a telephone booth filled with water; the booth is set in a desolate late evening New Mexican landscape, and in the distance a train approaches. The technical brilliance of this sleeve cannot be overstressed, especially when it is remembered that it was created ten years before digital retouching made this sort of picture montage relatively easy.

Artist: Pixies
Title: *Surfer Rosa*
Design: Vaughan Oliver
Label: 4AD

Artist: Fridge
Title: *Orko*
Design: Trevor Jackson
Label: Output

Artist: New Order
Title: *Blue Monday*
Design: Peter Saville
Label: Factory

Artist: Autechre
Title: *Chichlisuite 1 & 2*
Design: The Designers Republic
Label: Warp

Artist: Various
Title: *Artificial Intelligence 1*
Design: The Designers Republic
Label: Warp

Rob Mitchell
Co-director/A&R
Warp Records Ltd

In order to achieve these standards of technical excellence Hipgnosis needed generous budgets; and they got them. Powell states in his book *Classic Album Covers of the 70s* (Paper Tiger, 1994): 'It was a glorious time for indulgence: musically, creatively and, of course, financially'. Their notorious disregard for budgets[15] and the fact that they conducted themselves like rock stars (becoming almost as famous as some of the bands for which they worked) resulted in the dominance of the English music scene at a crucial time for sleeve design. The work of Hipgnosis, and the methodology they adopted in their dealings with record companies, musicians and the managers of musicians, constituted a radically new approach, and they raised sleeve design to a new and elevated plateau of public interest; a level to which, it might be argued, it has never quite returned.

Powell and Thorgerson closed Hipgnosis in 1981. Powell moved into music videos – rightly sensing that they would surpass sleeve art as the record industry's dominant visual outlet. Thorgerson continued to design album covers (his eccentric elder statesman mien is a welcome ingredient in the current sometimes over-serious London sleeve design community). By the time Hipgnosis ceased to exist, they had joined their clients in a new musical category – Dinosaur. And their patrons – Led Zeppelin, Pink Floyd and Genesis – had become the focus of hatred for a new youth-culture explosion – punk.

By a curious irony, the Sex Pistols and their manager Malcolm McLaren, had moved into premises next door to the Hipgnosis office in Denmark Street, central London – the English Tin Pan Alley. Powell detected an icy wind of change: 'The music that inched out of their thick studio door clashed horribly with the delicate harmonies of Crosby, Stills & Nash emanating from ours. Daily, I sensed a malignant attitude in McLaren's mission – we were out, they were in. He was right.' McLaren's dazzling management of the Sex Pistols, and their subsequent success, formed the basis for the growth of punk. Jamie Reid, who designed the Sex Pistols' album covers, gave the movement its graphic style and since, on the surface, it was a

movement with no discernible ideological content – although perhaps a musical ideology was to emerge with the rise of the independent record sector – the graphic style became as important as the music.

The aesthetics of punk – ransom note typography, bin-liner chic, more thrift shop than Bauhaus – blew away the sophistication and refinement that Hipgnosis had brought to seventies sleeve design and replaced it with a genuinely iconoclastic visual language as radical, and as impenetrable to the uninitiated, as the psychedelic poster art of the previous generation. The big English record labels were caught in one of their periodic phases of looking the wrong way and the notion of the grandiose album cover was an early casualty of the new movement. Record labels were springing up overnight and punk graphics suited them perfectly. It was a cheap style and it kept sleeve production costs low.

Amongst the most successful labels that emerged in the punk era was Stiff. Fractionally less anarchic than its rivals, Stiff had a nearly discernible musical ethos based around a few groups with the ability to make intelligent music *and* the occasional hit record. They also had an attractive and irreverent anti-corporatist approach to marketing records, which appealed to a new generation of record buyers (their name came from the US record industry slang term for a flop record). And in their sleeve designer Barney Bubbles they had one of their most valuable assets, and one of the great English sleeve designers. (The young Neville Brody also worked briefly at Stiff.) Bubbles' early pre-Stiff sleeves give little indication of the powerful and expressive work he was to produce for the label. His best work was invariably for Ian Drury and the Blockheads, an archetypal Stiff act: his wallpaper sleeve for their album *Do It Yourself* (Stiff, 1979) – a remarkable sleeve which was available in 52 different versions – and his famous Russian Constructivist-inspired logo for the group stand as lasting tributes to this great designer who committed suicide in 1983.[16]

Artist: The Stooges
Title: *Funhouse*
Art direction: Robert L. Heimall
Photography: Ed Caraeff
Label: Elektra

Artist: Malcolm Boyd
Title: *Are You Running With Me Jesus?*
Photography: Robert L. Frank
Label: Columbia

Artist: New Order
Title: *Brotherhood*
Design: Peter Saville
Photography: Trevor Key
Label: Factory

Artist: Velvet Underground
Title: *1969 Live*
Design: Ernst Thormahlen
Label: Verve

Artist: Sex Pistols
Title: *Gun Control*
Label: Bootleg

John Hamilton
Art Director
Penguin Books

During most of the seventies American sleeve designers enjoyed an era of growth and expansion, and many important figures emerged during this decade. No one personified the maverick spirit of sleeve design better than Cal Schenkel. Closely associated with Frank Zappa, Schenkel's *Sergeant Pepper* lookalike cover *We're only in it for the Money* (Warner Bros, 1968) is a work of parodic genius, and his covers for subsequent Zappa sleeves mined a rich seam of iconoclastic imagery. However, Schenkel's finest cover was for Captain Beefheart's *Trout Mask Replica* (Reprise, 1975): a bravura statement emphatically capturing the psychedelic swamp blues of the eccentric Captain. Schenkel currently lives and works in Pennsylvania.[17]

Another Zappa sleeve designer, Neon Park (real name Martin Muller) contributed greatly to the notion of the sleeve designer as a maverick figure unhindered by commercial considerations. He described his style as 'psychopop' and although he lacked the visual refinement of Schenkel, he consistently produced sleeves exhibiting a similar visual anarchy. His most famous Zappa sleeve, *Weasels Ripped My Flesh* (Reprise, 1970) uses a cheesy pulp-fiction book jacket style of illustration and shows a close-up of a matinee idol shaving with a live weasel; the startled animal is tearing at the grinning Lothario's cheek, and blood flows freely from the wound. The sleeve was initially banned by Warner Bros, but Zappa cajoled them into releasing it. Even so, the sleeve printer was reluctant to print it. Deeply offended he called it 'the most degenerate thing I have ever seen' and his staff were unable to overcome their revulsion and pick up the original painting.[18] Park was to find lasting fame as the sleeve designer for Little Feat and the series of albums they made in the seventies featured Park's eccentric talent to great effect.

In contrast to the abundance of illustrative covers, the period also saw the photographic album cover reach a new maturity of expression. The two leading practitioners at work in seventies America were Norman Seef and Moshe Brakha. Seef's photographic style – usually black and white with a radical disregard for the lighting conventions of the time – introduced into the music industry ideas of portraiture from the world of fashion. Brakha's work was distinguished by dramatic cropping and unusually heightened colour (a technique that presaged the cross processing much in vogue amongst record business photographers during the late eighties and early nineties). Brakha's sleeves for Ritchie Havens' *The End of the Beginning* (A&M, 1976) and Boz Scaggs' *Silk Degrees* (CBS, 1976) show him at his inventive best. He currently works in advertising.

In design, John Berg at CBS in New York continued to make an indelible mark with his elegant and intelligent art direction, especially apparent in his sleeves for early Bruce Springsteen records.[19] In California, the British-born designer John Kosh developed a slick, commercial and faintly retro style usually incorporating high-quality photography and up-to-the-minute production techniques. He was much in demand by the seventies LA rock aristocracy and his sleeves for The Eagles and Linda Ronstadt give a foretaste of the more commercial and 'packaged' covers of the eighties.

I said to myself when I was 28 that this was not a job to be doing in your thirties, and certainly not in your forties
Peter Saville, interview in *Design Week*, 1998

As the seventies morphed into the eighties, sleeve design reflected the great cultural and political changes ushered in by the 'greed is good' decade. The naive idealism that had always been a part of the record industry finally died and there was no longer any room for the intuitive approach to sleeve design: it was the era of branding and marketing and records were no longer designed, they were 'packaged'. At the same time, a new generation of English designers emerged. They distinguished themselves from their predecessors by their immersion in the principles of modernist European design and typography – some of them were the disciples of Herbert Spencer and Jan Tschichold – and they took an interest in, and derived inspiration from, cultural and artistic movements other than pop culture.

Artist: Section 25
Title: *Always Now*
Design: Peter Saville
Label: Factory

Artist: Gavin Bryars
Title: *Three Viennese Dancers*
Design: Barbara Wojirsch
Label: ECM

Artist: Jon Balke/Oslo 13
Title: *Nonsentration*
Design: Barbara Wojirsch
Label: ECM

Artist: Captain Beefheart
Title: *Trout Mask Replica*
Design: Cal Schenkel
Photography: Ed Caraeff/
Cal Schenkel
Label: Reprise

Artist: Tortoise
Title: *TNT*
Design: Tortoise
Label: Thrill Jockey

Adrian Shaughnessy
Creative Director
Intro

The leading figures were Malcolm Garrett, Neville Brody, Vaughan Oliver and Peter Saville. This quartet represented a new generation of art school-trained designers and perhaps for the first time formal graphic design thinking exerted a sustained and discernible effect on sleeve design. Each of these figures made substantial contributions to the history of sleeve design – two of them (Oliver and Saville) still do.

Brody's involvement in the record industry was the most short-lived of the four and by the mid-eighties he had abandoned record covers in favour of magazines, where his contribution has been justly lauded. But his early-eighties sleeves for Cabaret Voltaire, 23 Skidoo, and his work for Fetish Records, helped define eighties graphic style almost as much as his magazine work. Brody is on record as saying how lucky he was to have enjoyed the freedom afforded by sleeve design at a critical stage in his development as a graphic designer.

After art school in Manchester, Malcolm Garrett designed punk sleeves. His work for the Buzzcocks is only slightly less celebrated than Jamie Reid's work for the Sex Pistols. Later, Garrett formed Assorted Images where his high-profile work for prototypical eighties groups Culture Club, Duran Duran and Simple Minds helped turn his company into a sort of renegade version of the many burgeoning design consultancies forged in the white heat of the eighties financial boom. These companies experienced meteoric growth – unknown to previous generations of designers – and in order to serve their masters in the yuppie industries of financial services, property and retail, they developed elaborate and sophisticated design philosophies and practices which appealed greatly to the corporate eighties mentality. Garrett mimicked these Porsche-era designer pieties and applied them – with added panache – to the sleeves he designed. He gave pop groups corporate identities and packaged them like branded products. But he did it with charm and an innate irreverence unthinkable amongst the design consultants whose ideas he subtly subverted. The record companies loved it and flocked to his door.

Vaughan Oliver started his working life at one of the eighties most famous and audacious design groups – Michael Peters. He didn't stay long, and it seems unlikely that a designer with Oliver's visionary qualities would have found fulfilment in mainstream design practice. Almost inevitably it was to sleeve design that he turned. A chance meeting with Ivo Watts-Russell, the founder of 4AD, an outré and idiosyncratic record label, resulted in the establishment of one of the most successful and enduring client/designer relationships in modern graphic design (although the relationship has now ended with Oliver severing his ties with the label). At 4AD, Oliver found the freedom to pursue his interest in arcane and often menacing imagery. His work refuses categorization; a skein of influences combine to create a poetic visual world that barely qualifies as graphic design. By far the least conventional of the eighties big four, Oliver has rarely strayed from sleeve design. He continues to produce work of enigmatic beauty; his sleeve for Icelandic band GusGus' *Polydistortion* (4AD, 1997, see pages 24 and 25), designed with Chris Bigg, reveals his astute handling of type and image, and his assured art direction.

Despite his protestations that he is too old for sleeve design, Peter Saville continues to design record covers for a diverse group of musicians and bands; Suede (see pages 32 and 33), Goldie and Pulp are recent clients. He trained in Manchester with Malcolm Garrett, and found an intelligent and brave patron in Tony Wilson, founder of the Factory label. The rise and fall of Factory is well documented, but while the label thrived it gave Saville the opportunity to create a body of work that was to become as celebrated as that of any sleeve designer in the short history of the record industry.

The most lasting achievement of Saville's Factory sleeves is that they prompted a generation to regard graphic design, for perhaps the first time, as an activity worthy of the same respect accorded to the music. Prior to Saville, it might be guessed that music fans responded to the *sensationalism* of sleeve design: post-Saville this was to change. Graphic design ceased to become an invisible

art; it became cool; typography became cool; white space became cool; pictorial restraint became cool. And it is surely no exaggeration to suggest that Saville almost single-handedly inspired a generation of wan youths, eager to acquire his eloquent powers of expression and clutching copies of Joy Division's *Closer* (Factory, 1980) and New Order's *Power, Corruption & Lies* (Factory, 1983), to fill up the art schools of Britain.

Saville still produces sleeve designs of breathtaking assurance. He surrounds himself – much as Hipgnosis did before him – with the best photographers, digital retouchers and technicians, yet his work continues to display his unique louche genius and keen visual intelligence. Saville's work has always attracted the art world, quick to recognize that his inspired appropriation of imagery was akin to techniques used by artists working in the more rarified world of fine art. Yet, such is the level of craft, especially typographic craft, which Saville brings to his work, he also appeals strongly to the traditionalists of graphic design. Indeed to such a degree that he was invited in the early nineties to join Pentagram, the venerable British design company founded in the sixties, and still today retaining a romantic aura of typographic craft and traditional design practices. The liaison did not work and Saville returned to being his own master: the Peter Pan of sleeve design, he remains perennially fresh and on the beat.

Elsewhere another trend was emerging. On both sides of the Atlantic, music and fashion embraced with an intensity not seen before, and eighties sleeves revealed the cosmetic alchemy of the stylist, the make-up artist and the hair-dresser. Fashion photographers Herb Ritts, Annie Leibovitz and Steven Meisel, switched effortlessly from the pages of *Vogue* to the album covers of Madonna and Cyndi Lauper, although perhaps the era is best defined by the partnership of photographer Jean-Paul Goude and singer Grace Jones, a potent melding of rock chic with the catwalk. The record companies pushed this trend in sleeve design with particular gusto in order to capitalize on the plethora of media outlets that opened up during the eighties – the glossy magazines and the arrival of MTV. And in due course the all-pervading pop video – the sine qua non of eighties record companies – came to supplant the album cover as the most important visual platform for the record industry.

Before the end of the decade, another figure emerged who was to make an important contribution to the subject. Mark Farrow's sleeve designs for the Pet Shop Boys ushered in an era of refinement and minimalism somewhat at odds with the prevailing design trends of the time. Farrow was assisted in his pursuit of graphic purity by the Pet Shop Boys themselves, who in common with a new generation of savvy musicians and managers, insisted on clauses in their contracts which gave them control over the design of their sleeves. It is a development that has almost single handedly prevented sleeve design from atrophying, and while it cannot be said to always guarantee brilliant design, it at least allows for distinctive and rebellious sleeve art to bubble to the surface. Although there are numerous examples of fruitful partnerships between designers and musicians – Me Company and Bjork; Stylo Rouge and their early work for Blur – nowhere is this alliance of disciplines better illustrated than in the prolific relationship between Mark Farrow and the Pet Shop Boys.

Farrow remains a potent and influential force in the nineties. His beguiling parody of medicine packaging for *Ladies and Gentleman we are Floating in Space* by Spiritualized (Dedicated, 1997)[20] represents a return to the days of grandiose packaging not seen since the pre-punk era. But Farrow represents only one strand of design thinking in the pluralistic nineties. As we have seen, the new hard line adopted by the record industry stands in marked contrast to their previously sympathetic approach, and as we have also seen, the sleeve designers of the past two or three decades operated in an atmosphere of encouragement and acceptance, very different from the conditions that pertain today. Yet if we examine the micro-climate in which intelligent sleeve design currently exists it is clear that it is refusing to die. Despite the loss of the vinyl sleeve, despite the rise of the music video, despite the record companies' reliance on Spice Girls-type disposability, and despite the uncertainty coursing through the industry, sleeve design remains alive and oddly vibrant.

Artist: Gil Mellé
Title: *The Andromeda Strain:
Original Electronic Soundtrack*
Art direction: John C. LePrevost
Design: Virginia Clark,
assisted by Joel Shapiro
Photography collage:
Ruth Corbett
Label: Kapp

Artist: The United States
Of America
Title: *The United States
Of America*
Photography: Gary Margolis,
Sgt. William Kerby USMC
Label: CBS

Artist: Joy Division
Title: *Unknown Pleasures*
Design: Peter Saville
Label: Factory

Artist: Velvet Underground
Title: *The Velvet Underground
and Nico*
Design: Andy Warhol
Label: Verve

Artist: Neu!
Title: *Neu!*
Design: Klaus Dinger
Label: Brain

Julian House
Designer
Intro

What is it that, despite the heroic efforts of trendy magazine editors, whiz kid television producers, record sleeve designers and the like, makes modern Britain so fatally unsleek a country, so strangely 'provincial' in the global scheme of things?
Gilbert Adair *Surfing the Zeitgeist*

In the cool postmodern nineties, pop culture might be said to be the dominant cultural strain. Britain now has a Prime Minister who once played in a rock band; and the 'leader of the free world' blows a mean tenor saxophone. Pop music has come in from the cold and as a consequence it has been denuded of its culturally subversive role. And if this is the case then it must also apply to record sleeves. It seems barely conceivable, in this peculiar millennial period, that an album cover might act as a catalyst for cultural change, as once might have been justifiably claimed of a number of famous sleeves. Who would dispute the notion that the topless women on Jimi Hendrix's *Electric Ladyland* (Track, 1969) gave an impetus to the burgeoning sexual revolution of the sixties? Who can say what effect David Bowie wearing a dress on the cover of *Hunky Dory* (RCA, 1971) had on young gay men around the world? Who could measure the impact on young black people of Bob Marley's confident and defiant dreadlocked image on his seventies album covers?

But the loss of a culturally significant role for sleeve designers is compensated for by a new and crucial role in the evolution of visual culture. As J.G. Ballard notes in his book *A User's Guide to the Millennium*, we live in a post-literate world where the written word has been supplanted by visual communication. And if this is so, then the search is on for more sophisticated modes of expression. But we look in vain if we turn to orthodox practitioners of graphic design for leadership: the big design groups who effectively control huge tranches of graphic communication seem determined to reduce graphic design to a marketing tool in order to satisfy their paymasters in the big corporations and by so doing drain the medium of vibrancy and deny it its undoubted power of expression. Instead we must look to rogue individuals; small bands of designers dedicated

to innovation and expressive design, and nowhere is this sense of adventure stronger than amongst the designers of record sleeves.

Record cover designers have traditionally performed a sort of unacknowledged pathfinder role for visual communication and continue to do so, despite the trauma currently infesting the record business. Sleeve design remains a field of innovation and its influence can be seen in numerous areas. However, scant recognition is forthcoming for this pioneering work at the visual coalface. Amongst the great and the good of the design world – partners in big design consultancies, senior figures in art schools, and those who judge design awards – it is a widely held view that sleeve design is a frivolous activity unworthy of the attentions of professional designers. Sleeves are seen as merely the tribal markings of youth culture, whereas real design by contrast concerns itself with strategy, branding and 'problem solving'.

The flaw in this thinking is that amongst large sections of an increasingly sophisticated and educated populace, design is culture. The demand for the highest standards of design extends to all aspects of modern life – furniture, clothes, electrical goods, book jackets. And in visual communications this attitude has resulted in an interest in, and acceptance of, radical ideas. No one understands this better than the more progressive advertising agencies who realize that sharp media-literate consumers will no longer be inspired by crass and unthinking advertising, and as communicators they make the big design groups with their weedy reliance on neutral 'design solutions', look ponderous, unadventurous and locked into old notions of consumer gullibility.

The clothes designer and retailer Paul Smith is a powerful advocate of innovation in design. In a recent article he posed the question, 'Why does everything look the same?'.[21] He has a point; magazines, retail environments, corporate logos, supermarket packaging – they are all blighted by endless cloning; design by copying. Smith practices what he preaches and his idiosyncratic approach to selling clothes has resulted in the creation

of a multimillion pound empire. But he has done it by adopting an uncompromising and unformulaic approach to design and communications.

In the UK, the maverick spirit that informs the best sleeve design can be seen seeping into the mainstream. The corporate identity for Orange, a leading mobile telecommunications business, is held up by both designers and business people as a brilliantly successful visual identity. But its minimalist sans-serif, lower-case appearance is arguably a descendant of late-eighties record sleeve work. Another much-discussed UK visual identity, and the source of heated debate between traditionalists and progressives within design and the business community, is the new livery for the country's national airline, British Airways. Seen as a radical departure from conventional branding, the identity is based around a series of ethnic designs applied to the tail planes of BA aircraft. The effect is charming, refreshing and yet perfectly homogenous. This 'same yet different' approach is by no means confined to record sleeves, but it has undeniably been a feature of numerous album campaigns where a family of sleeves and posters cluster around a central design, each with its own identity yet sufficiently different to excite interest. Standard practice in sleeve design for the past decade or so, here we find it successfully incorporated into a global brand.

This is not to say that record sleeve design is the only place to find graphic innovation; far from it. There are wonderful graphic designers producing work of the highest quality in many other sectors. But this work tends to be done away from the main avenues of daily life – in the arts, in the top end of the retail sector, and so on. Yet go to any branch of Woolworth's and next to the cuddly toy counter you will find CD covers by Vaughan Oliver (4AD), Peter Saville (Pulp), Tom Hingston (Massive Attack) and Me Co. (Bjork), emphatically reinforcing the notion that sleeve design remains the only place in mainstream commercial life where visual innovation has a permanent foothold.

So if the best sleeve designers (many of them featured in this book) are denied the credit given to designers working in other areas of design, then at least they can take pride in their role as innovators mapping out future landscapes for graphic communication. Yet few sleeve designers admit to, or recognize, this role. Instead they cite the usual enticements when explaining why they are drawn to music-related design: freedom of expression, an unwillingness to contend with the compromises prevalent in corporate graphic design. Many, however, will claim inspiration from the music itself, and just as the new breed of nineties musician is often defined by a radical eclecticism, the same is frequently true of the present-day music designer.

In fact, viewing the work included in this book – work mainly produced over the past two years – the salient characteristic of nineties music design appears to be *rampant eclecticism*. There is no dominant nineties visual style, just as there is no dominant musical style – drum and bass sits beside lo-fi; trip hop happily co-exists with Japanese noise; dub lies down with speed core. The reasons for this stylistic diversity are manifold; but perhaps the single most important factor is the availability of cheap sampling equipment. This has given musicians, and non-musicians – hence the cult of the DJ – access to an 'ocean of sound' (to borrow David Toop's phrase). Sounds, melodies, and musical fragments from every conceivable category of music are dredged up and played back as audio textures, reconstituted as unrecognizable soundscapes or transmuted into new music. An identical creative process is at work in graphic design. The new inexpensive digital technology and software has enabled free thinking and ambitious designers to extend their sphere of visual reference; there are no boundaries in the 'age of plunder'.

The consequence of this visual eclecticism is that nineties sleeve design is defined by an overwhelming number of trends and stylistic nuances. Perhaps the dominant trend – certainly the most interesting one – is the anti-design stance of many contemporary American bands. These young bands energetically avoid the conventions of graphic design with great relish. Their sleeves – often

Artist: Joni Mitchell
Title: *Hejira*
Design: Joni Mitchell
Label: Asylum

Artist: Captain Beefheart
Title: *Trout Mask Replica*
Design: Cal Schenkel
Photography: Ed Caraeff/
Cal Schenkel
Label: Reprise

Artist: Velvet Underground
Title: *The Velvet Underground
and Nico*
Design: Andy Warhol
Label: Verve

Artist: Pink Floyd
Title: *Wish You Were Here*
Design: Hipgnosis
Label: EMI

Artist: Los Lobos
Title: *El Pistola Y El Corazon*
Design: Jeri Heiden
Label: Slash

Rob O'Conner
Designer
Stylorouge

designed by the bands themselves – hark back to the amateurism of psychedelia and punk, but with the crucial difference that their choice of imagery is informed with intelligence and wit. Besides permanently holding two fingers up at the record industry and at conventional graphic design, these sleeves cock a snook at fashionable American graphic design, particularly the 'music + style' tendencies of the Ray Gun school – what design writer Rick Poynor has called 'car-crash typography'.[22] Instead their inspiration comes from the vernacular of daily life: comic books, TV cartoons and the folk art of modern commercialism. The work of Chicago label SKiN GRAFT exemplifies this trend (see page 45).

No sleeve comes closer to defining the era than Tortoise's *TNT* (Thrill Jockey, 1998, see page 63) which combines visual panache with untutored simplicity to make a bravura statement of restraint. The design, credited to the band, might theoretically have been produced at any time over the past thirty years, yet it is quintessentially nineties. Their record company (Thrill Jockey in Chicago) deny any deep understanding of the design except to say that the naive illustration is perhaps a reaction to the over-serious attention devoted to the group by the egghead school of rock criticism. And it is exactly this postmodern knowingness that characterizes the best nineties cover art.

The sleeve manifests yet another trend; a melding of the recording process with the presentation of the record itself. This, of course, has been a feature of sleeve design – especially jazz sleeves – for decades; ask a musician what they want on their sleeve and invariably they suggest pictures of their recording studio. For a new generation of musicians the recording studio bears little or no resemblance to the groovy clutter of a sixties jazz session. Instead, it is a world of computer screens and high-tech equipment that would not be out of place in a NASA flight deck. Tortoise pay homage to the process by which they made this record by appropriating the visual language of recordable CD packaging. They are not alone in this attempt to match process to presentation. The brilliantly presented series of CDs by the innovative Parisian clothes

design house A.P.C. takes this a stage further; the final design is indistinguishable from the studio master copies which are sent to the CD factory for manufacture (see pages 50 and 51).

A more designerly sensibility can be seen in the work of designer Stefan Sagmeister. Based in New York, Sagmeister has attracted a slew of big names: the Rolling Stones, David Byrne and Lou Reed. Perhaps it is his Austrian upbringing but one senses strongly his disjuncture with the conventions of pop culture. His work is intellectual, original and baroque in its complexity. Moreover, he seems unimpaired by the miserly dimensions of the CD and blissfully unrestrained by the manufacturing and production restrictions of the large record companies, so often the cause of bland and formulaic packaging. His drilled cover, with its uncaring destruction of text, for Skeleton Key's *Fantastic Spikes Through Balloon* (Capitol Records, 1997, see page 54) creates a daring and iconoclastic design.

In England, since the mid-eighties, the cult of dance music – and the huge on-rush of new electronic music that has swept in behind it: drum and bass, electronica, trip hop, and a dozen other categories – has had a pronounced and largely beneficial effect on sleeve design. The essentially abstract nature of this voiceless and word-less music tends to elicit an intuitive response from designers, and has resulted in the formation of a vast sub-genre of abstract sleeves employing hybrid imagery. And although it cannot be said that all sleeves in this category are of the highest quality, the best sleeves – usually for anonymous production teams with not the slightest interest in projecting pop-star images of themselves – have a primacy that is often missing in the covers of 'artists' with the need to project an image of themselves. For the major record companies this is another conundrum: how do you 'package' an artist who does not want to be packaged? It frequently results in insipid covers and the sort of eyewash music videos that clog up TV music channels.

Artist: Eels
Title: *Beautiful Freak*
Design: Francesca Restrepo
Photography: Ann Giordano
Label: Dreamworks

Artist: Blur
Title: *Blur*
Design: Yacht
Label: Food

Artist: Pulp
Title: *A Different Class*
Design: Blue Source
Label: Island

Artist: Beck
Title: *Odelay*
Design: Robert Fisher
Photography: Nitin Vadukul
Artwork: Zarim Osborn, Al Hansen
Label: Geffen

Andy Ross
'Boss'
Food Records

As the big labels flounder in their attempt to formulate a response to this, and other changes in a market place that resists attempts to control it, a number of labels have emerged offering a viable alternative. In the UK, the most celebrated example is MoWax. Founded by DJ James Lavelle the label has built a global cult following by releasing music with an irresistible blend of a dozen or so musical styles. And in the tradition of the great music industry label heads of the past, Lavelle is blissfully un-compliant with current industry conventions; in no area is this more apparent than in his enlightened approach to the visual presentation of his records. Working with designer Ben Drury, Lavelle has created an identity for his label that is unmistakable and although not a house style in the normal sense of that term, perfectly articulates the cool urban musical ethos of his label and is recognized around the world.

This high recognition factor has as much to do with the courageous refusal of the label to use the ubiquitous perspex jewel case. (Even the label's name is a plea for more vinyl records.) Lavelle scours the world for audacious packaging alternatives and each release attempts something different; the pizza box packaging for his UNKLE magnum opus, *Psyence Fiction* (see pages 68–71) offers visual wit and entertainment comparable to the great 'event' covers of the sixties.

The sleeves of German label ECM are unsurpassed in their measured articulation of the label's musical ethos. Founded by producer Manfred Eicher in 1969, ECM has trod a solitary road of individuality since its inception. Impervious to musical and stylistic fashions, working with his designers Barbara Wojirsch and Dieter Rehm, and a small band of extraordinary photographers, Eicher has created a body of work that goes beyond the mundane world of packaging, and hints at the transcendent fusion of sound and vision. ECM sleeves capture the austere aesthetic of ECM music; Nordic avant-jazz, epiphanic classical music from Eastern Europe, and chamber jazz by American musicians attracted to Eicher's sublime recording techniques. ECM stands alone as a paradigm of the independent record label.

Numerous other labels fight to keep sleeve design at the forefront of their operation. Many are represented in this book: Warp, Touch, Mute, Thrill Jockey and Nude.

But pop music demands pop sleeves, and the work of London-based designers Blue Source places them amongst the most refined practitioners of contemporary pop sleeve design. Their best covers exhibit typographic sophistication married to exquisitely art directed photography. Their sleeves are powerful commercial statements exuding the unmistakable polish of the fashion spread. Blue Source's inspired use of illustration (by Reggie Pedro) on a recent campaign for Gomez *Bring It On* (Hut, 1998, see pages 112 and 113) and their deployment of raw elemental photography (by Nick Waplington) for Puressence *Only Forever* (Island, 1998, see pages 91–93) reveal a sure-footed instinct for creating sleeves of undeniable modernity.

A more frenetic pop sensibility is offered by The Designers Republic, the Sheffield-based design team run by Ian Anderson. Their Dystopian-techno-graffiti-meets-Disney-in-cyber-space style enjoys fame beyond the confines of the music industry – due to the company's work for computer games, rather than its more prolific sleeve work. A host of unofficial web sites pay homage to the apocalyptic visual algebra of DR, but their recent abandonment of an obviously computer-generated visual style for a more fractured and organic style, indicates their desire to develop. This recent departure can be seen in their work for Autechre (see pages 106 and 107).

This investigation into the history and current predicament of sleeve design has confined itself to Britain and America. But this Anglo-American view of the subject is no longer sustainable. French pop music, long reviled as the epitome of Euro-naffness, has mutated into a vibrant and original brew, largely as a result of the French immigrant population finding a voice. This has resulted in music – and covers – of unexpected potency. Small labels like the Paris-based Source commission work of great beauty (see pages 40–43), and the independent rap labels of Paris have all the fizz and swagger of their US counterparts.

Artist: Neu!
Title: *Neu!*
Design: Klaus Dinger
Label: Brain

Artist: Hawkwind
Title: *In Search Of Space*
Design: Barney Bubbles
Label: United Artists

Artist: Kraftwerk
Title: *Autobahn*
Design: Emil Schult
Label: EMI

Artist: Kraftwerk
Title: *Radioactivity*
Design: Emil Schult
Label: EMI

Artist: Faust
Title: *Faust*
Label: Polydor Germany

Daniel Miller
Chairman
Mute Records

In Germany and Switzerland, there are similar rumblings. Both are countries with venerable graphic design heritages – and vibrant contemporary music scenes – but little evidence of this exists on their record covers. However, this is changing. The work of some young Swiss designers shows an inspirational disregard for the conventions of commercial music packaging: place the cassette covers for Pronoise (see page 123) in the pages of one of the journals devoted to contemporary fine art, and they would not look out of place.

Perhaps the future for sleeve design rests in the Third World. World Music exerts an increasingly strong attraction on music fans, their palates jaded with the relentless thud of Western pop; but this music sounds best when accompanied by authentic packaging, as anyone who has bought cassettes in the souks of Morocco, the streets of Rio, or the markets of Bombay, will attest. Nowhere is this more clearly demonstrated than in the vibrant Jamaican music scene. Sleeve design may never have reached the heights achieved by Jamaican music – there has been no Bob Marley or Augustus Pablo of reggae sleeve design – but Jamaican record covers have always exhibited a raw vernacular power, much loved by admirers of the music.

For the weary sleeve designer an old battle is about to be re-enacted: the imminent adoption of a new format to succeed the CD. The record industry's quest for the definitive format – or at least a format that enables them to sell their back catalogues all over again – is unrelenting. There are a number of likely candidates: Mini-Disc already exists and is showing signs of persistence; DVD – an audio and video carrier – looks certain to establish itself; recordable CDs are already with us; other formats wait their moment. The one inevitability is miniaturization; this is a war where the spoils will go to the smallest. But miniaturization is no friend to sleeve designers, so despite all the furious innovation contained in this book the battle might finally be lost, and sleeve design may cease to be an area of free expression and innovation.

However, the most likely consequence of the proliferation of formats will be that the record-buying public will turn to the Internet, as musicians increasingly bypass the conventional record industry and go straight to consumers. Already a small band of teenage music fans, growing up in households connected to the World Wide Web, have been lured by the siren call of the flickering web page and the Audio Download. They have abandoned record shops and they no longer read the music press. Instead they get music and information online. Already a number of hardware manufacturers are readying themselves to release Walkman-like players that will capture music via the Internet, store it as raw data, and allow playback at any time. Of course for sleeve designers this sounds like the death – at last – of the record sleeve.

But for the adventurous designer this need not be the end of the road; perhaps the next Peter Blake, Neon Park or Peter Saville will be a web page designer. The scope for visual engineering is vast and in many respects the Internet offers greater potential for the genuinely ambitious designer than the printed record sleeve: animation, book length amounts of text, film clips, even remix facilities. Consequently the Internet may turn out to be sleeve design's saviour, and designers should embrace it just as the early pioneers of graphic design were quick to see the potential of the cardboard sleeve. However, traditionalists are allowed two regrets: you can't walk down the street with a web page under your arm and you certainly can't roll a joint on one.

Adrian Shaughnessy

Notes

1 *1000 Makers of Music*
Paul Du Noyer
(*The Sunday Times*, 1997)

2 *This Rimy River*
Vaughan Oliver and v23
(Exhibition catalogue, 1994)

3 Conversation with the writer in 1998.

4 Freeman was ultimately to play an important role in the evolution of sleeve design, along with David Bailey, who performed a similar role for the early sleeves of the Rolling Stones. Freeman's photography for the Fab Four – vastly superior to the customary stilted publicity shots used by early-sixties British beat groups – revolutionized the style of photography used by pop groups.

5 *Pop Art. A Continuing History*
Marco Livingstone
(Thames and Hudson, 1990)

6 Ironically, Berman is perhaps better remembered today as one of the faces on the front cover of *Sergeant Pepper*: selected for inclusion by Peter Blake, he appears on the cover between Tony Curtis and the English comedian Tommy Handley.

7 Amongst Beuys' most interesting sleeve work is a limited edition of signed and numbered boxes called *Sonnenscheibe*. Each box contains a copper master-mould of a record and two pieces of his beloved felt. Duchamp's *Rotorelief*, a gloriously ambitious construction, is also usable as a wall hanging. It is a series of six discs, each containing two optical-effect illustrations by Duchamp. A small motor inside each construction drives a turntable which causes the optical illustrations to rotate. Each edition is signed by the artist.

8 Norman Seef and John van Hamersveld are credited with 'layout design'. Both were key figures in seventies sleeve design, although their role in the creation of *Exile on Main Street* appears suitably low key.

9 *The Album Cover Art of Soundtracks* Jastfelder/Kasseel
(Little, Brown, 1997)

10 *Cain's Book*
Alex Trocchi
(John Calder, 1963)

11 *Waiting for the Sun*
Barney Hoskyns
(Bloomsbury, 1996)

12 Many musicians have designed their own album covers – Bob Dylan, Joni Mitchell, Paul McCartney – but few designers have recorded their own records. Besides Hapsash, it is a feat also achieved by The Fool with *The Fool* (Mercury, 1968); Mati Klarwein, famous for his ethno-surreal cover art for Miles Davis, recorded an album with Per Tjernberg called *No Man's Land* (Rub a Dub, 1997); and perhaps most successfully of all, contemporary English artist/designer Russell Mills with *Undark* (t:ime recording, 1996). At the time of writing Mills was engaged in a second recording. Examples of designers appearing on their own record covers are hardly more common, however Peter Saville can be seen posing on his cover for Suede's single *Film Star* (Nude, 1997, see page 32). Saville's languorous pose in the back of a limousine is suitably authentic.

13 Interview with David Widgery. *Days in the Life; Voices from the English Underground 1961–71*
Jonathan Green
(Pimlico, 1998)

14 *Time Travel:
From the Sex Pistols to Nirvana: Pop, Media and Sexuality 1977–96*
Jon Savage
(Vintage, 1997)

15 I began my working life as a trainee designer in the sleeve design department of one of the great (but at the time fast fading) British record companies. In a desperate – and reluctant – bid to gain some much-needed credibility, the ageing regime that ran the company decided to commission Hipgnosis to design a sleeve for one of the label's less geriatric artists. In the normal course of events this would have been handled by the in-house design team, but tradition was dispensed with and Hipgnosis were instructed to proceed with a photo shoot and the creation of a sleeve. In due course a bill was submitted. The cost of the shoot caused apoplexy amongst the elderly codgers who ran the company and particular exception was taken to the cost of Hipgnosis' catering expenses. Inter-departmental memos were exchanged on the subject for weeks afterwards. AS

16 For a fuller appreciation of Barney Bubbles see *Eye* (No. 6, Vol. 2)

17 Cal Schenkel has a website: www.RALF.com

18 Interview with Neon Park in *LA Magazine* 1980

19 At this time most of the big US labels employed powerful – often brilliant – in-house art directors to oversee this process of graphic extravagance, and some were destined to play major roles in the development of sleeve design: William S. Harvey at Elektra; John Berg and Bob Cato at CBS; Glen Christensen at Asylum; and Paula Scher, also at CBS. In England the notion of powerful art directors running big sleeve design departments was equally prevalent. Amongst those who made a valuable contributions was the late Fabio Nicoli at A&M, whose subtle art direction enhanced many English sleeves. Other figures – invariably strong characters able to place their creative thumbprint on to the sleeves of their employers – whose names can be found on numerous important album covers, include John Pasche at Chrysalis, Roslav Szaybo at CBS UK, and in more recent times Mike Ross at A&M, and Cally Calloman at Island.

20 The money Dedicated spent on the Spiritualized packaging would normally be spent on conventional record industry marketing initiatives. As things stand today this usually means promotional activity targeting radio stations, journalists and other decision-makers. The consequence of this is that the consumer is neglected and the record companies have lost the art of speaking directly to the record-buying public; their reasoning is that why bother with attractive packaging when the fate of most records is decided by radio stations. Dedicated proved that this philosophy is not always true.

21 Article in *Independent On Sunday*

22 Essay by Rick Poynor, *Paganini Unplugged David Carson* in *Design Without Boundaries*
(Booth-Clibborn Editions, 1998)

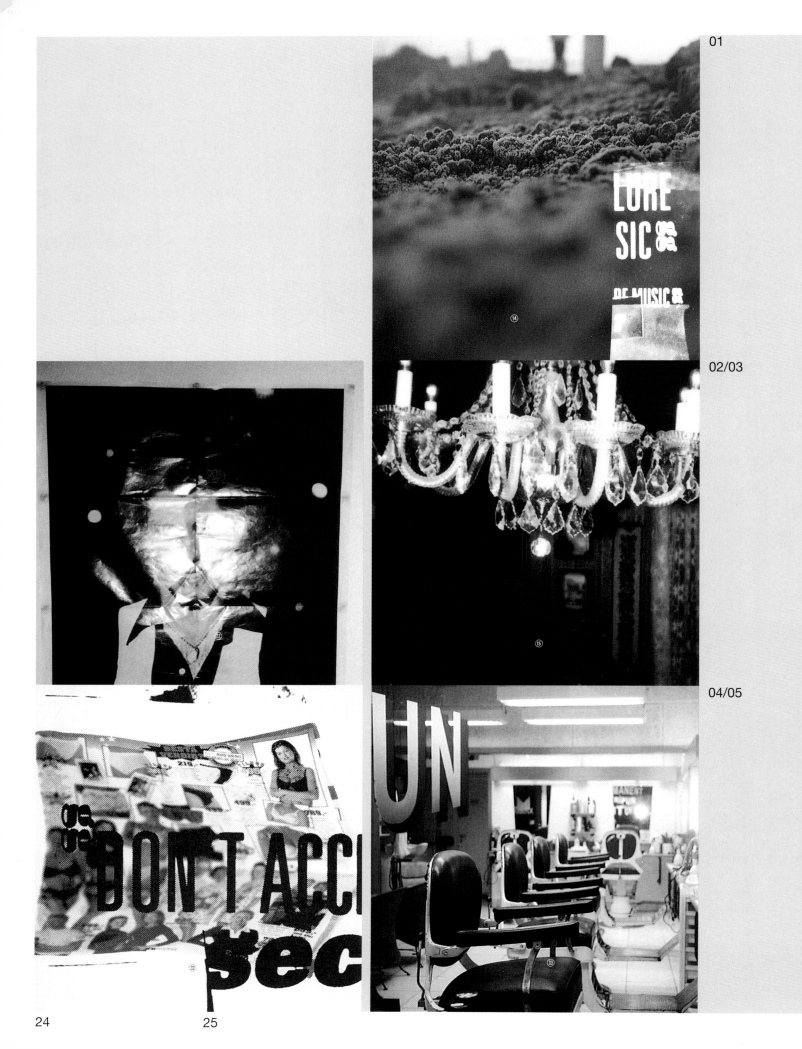

DAD D
7005

GusGus
Polydistortion

CD cover and booklet.

Art direction and design:
Vaughan Oliver, Chris Bigg @ v23
Photography:
Paul Bliss (front cover)
Eva Mueller (back cover)
Steph (03)
All other photography:
Vaughan Oliver, Chris Bigg @ v23
4AD
1997

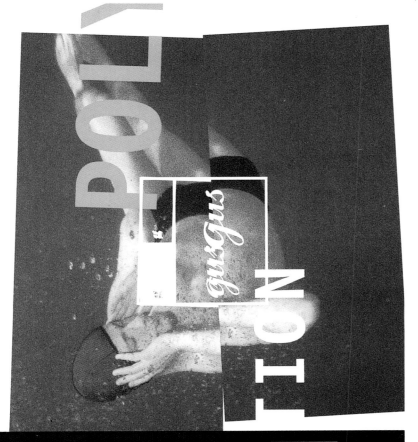

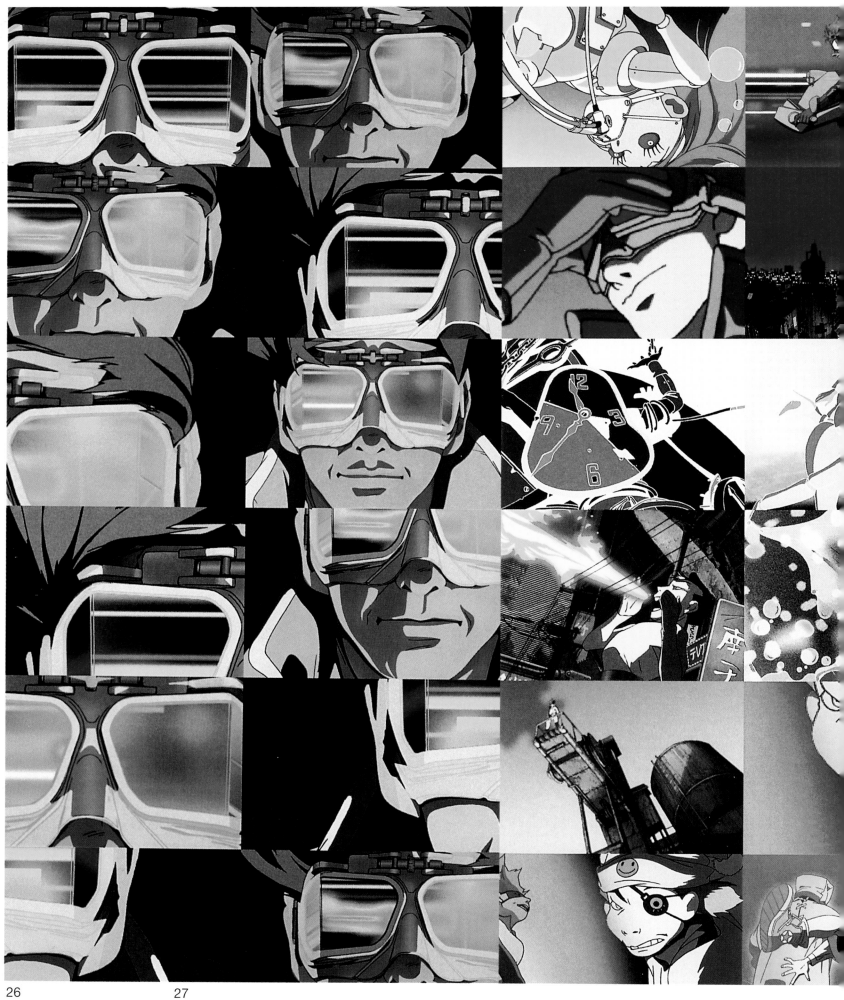

RS
95065

Ken Ishii
Jelly Tones

12" inner bag details and front.

Art direction: Yasanobu Yamashita
Animated video: Kouji Morimoto
R & S Records
1995

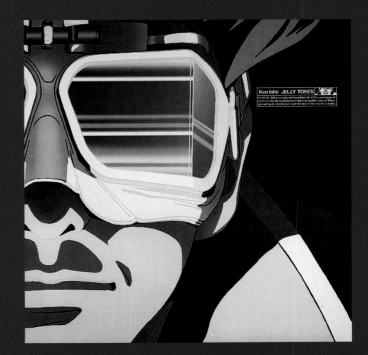

Ken Ishii
Echo Exit

12" outer sleeve with die-cut holes
revealing inner bag.

Art direction: Yasanobu Yamashita
Animated video: Kouji Morimoto
R & S Records
1997

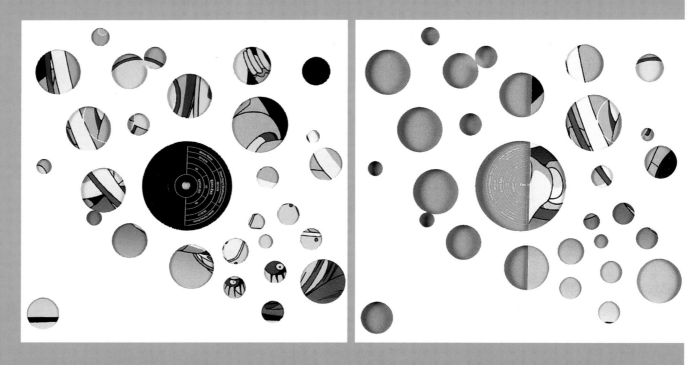

10Mute 217

Add N to (X)
Little Black Rocks
In The Sun

10" hexagonal vinyl disc
in fold-out sleeve.

Design: P.A. Taylor
Mute Records
1998

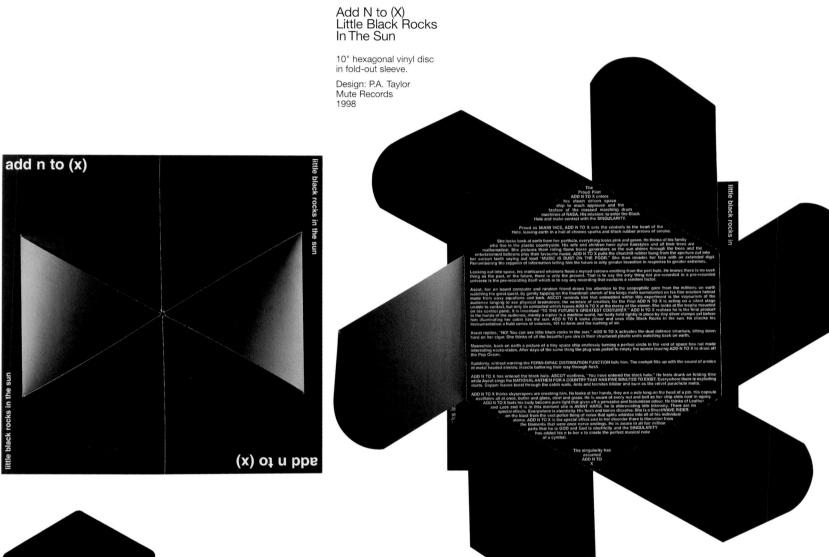

TruPak:
12

Orbital
Orbital TruPak:12

Limited edition promotional package
sent out to licensees of London
Records around the world containing
vacuum packed CD, video and plastic
information cards. Two of the information
cards use a simple interconnecting
matrix to provide Orbital's discography
and a track list for the CD sampler.

Design: Simon Kennedy, Paul Winter
@ Lab Projects
Internal
1996

Suede
Trash

CD front.

Cover by Nick Knight, Peter Saville,
Brett Anderson, Paula Thomas, Travis,
Stefe Seal
Design: Howard Wakefield
@ The Apartment
Nude
1996

Suede
Lazy

CD front.

Cover by Nick Knight, Peter Saville,
Brett Anderson
Paintbox: Stefe Seal
Design: Howard Wakefield
@ The Apartment
Nude
1997

Suede
Film Star

CD front.

Cover by Nick Knight, Peter Saville,
Brett Anderson
Paintbox: Stefe Seal
Design: Howard Wakefield
@ The Apartment
Nude
1997

Suede
Saturday Night

CD front.

Cover by Nick Knight, Peter Saville,
Brett Anderson
Design: Howard Wakefield
@ The Apartment
Nude
1996

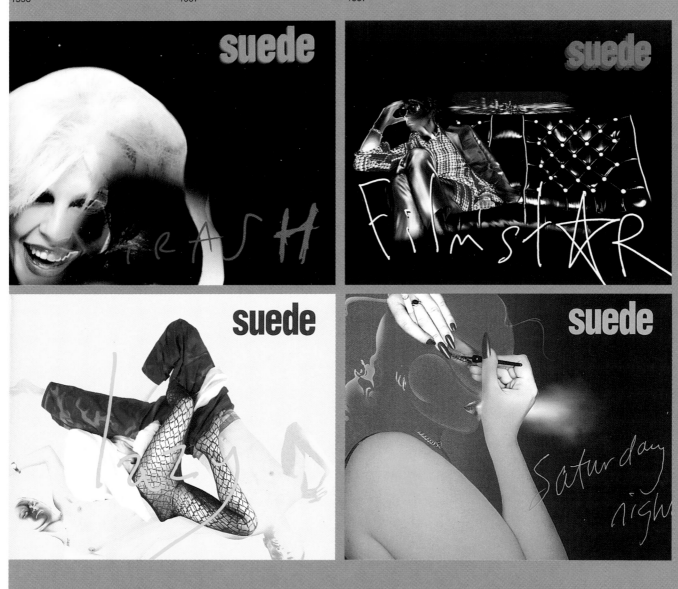

Suede
Sci-Fi Lullabies

CD inner spread.

Image: 'Hidden' by John Kippen
courtesy of the Photographer's
Gallery, London
Art direction: Peter Saville
Design: Howard Wakefield
@ The Apartment
Nude
1997

CREC
SD240

Toaster
Craska Vegas EP

CD front, back and logo detail.

Design: Mark Breslin @ State
Creation Records
1998

CRESCD 240

℗&© 1998 creation records ltd.
a creation records product
109x regents park road, london, nw1 8ur
distributed by 3mv/vital

01 peoples' peoples
02 60ft rocket
03 jamaican room
04 phoneheads

TOASTER

craska vegas ep

TOASTER

CREC SD279

CREC SD279 X

CREC D225L

Saint Etienne
Sylvie

2 x CD fronts.

Design: Steve Rowland/
Paul Kelly @ Phantom Industries
Original eye illustration by Big I
Creation Records
1998

Saint Etienne
Good Humor

CD front and fold-out inner with disc.

Design: Steve Rowland/
Paul Kelly @ Phantom Industries
Photography: Paul Kelly
Creation Records
1998

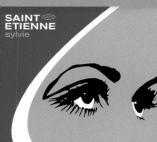
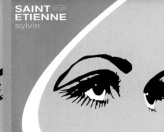

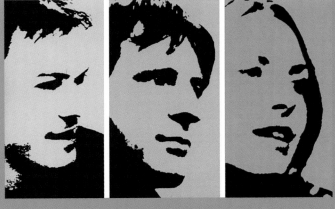

Ryoji Ikeda
+ / −

CD front and booklet.

Design: Touch
Designer: Jon Wozencroft
(from an idea by Ryoji Ikeda)
Touch
1996

Ryoji Ikeda + / −

+

+.

−

−.

headphonics (1995-96)

01 headphonics 0/0
02 headphonics 0/1
03 headphonics 1/0

+ / − (1996)

04 +
05 +.
06 +..
07 −
08 −.
09 −..
10 + / −

Oval
Dok

CD front, label and inner detail.

Design: Êndo Ritsuko
& Christopher Charles
Thrill Jockey
1997

The Grassy Knoll
III

CD bound with printed elastic band.

Design: Chika Azuma
Cover art: Mark Rothko
Antilles/Verve
1998

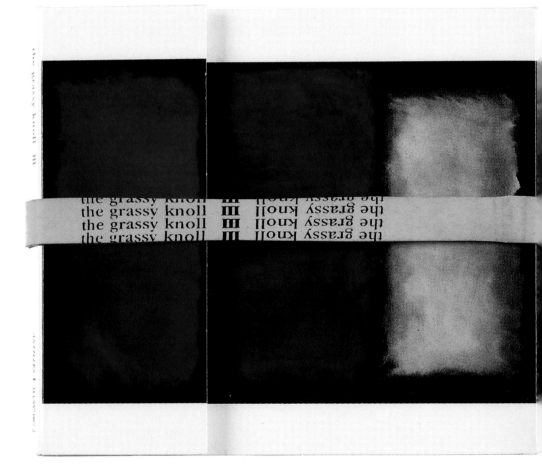

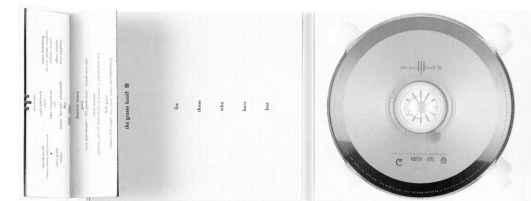

D-UHF-
CD20

Stereolab
Aluminum Tunes

Screenprinted fold-out cardboard
CD sleeve.

Design: Stereolab/House @ Intro
Duophonic Ultra High Frequency Disks
1998

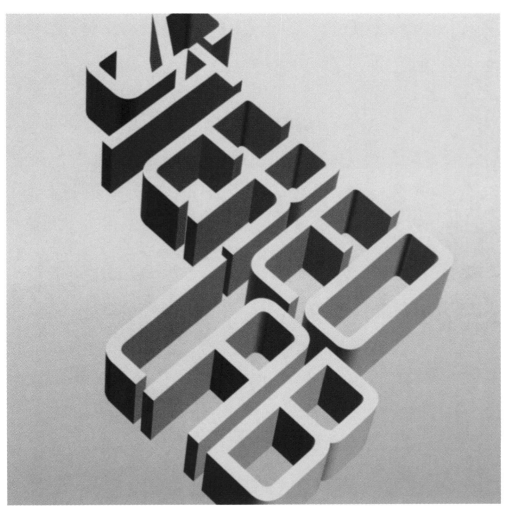

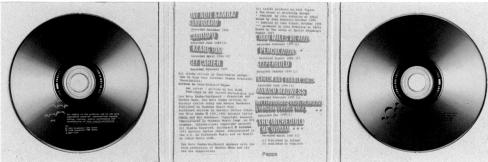

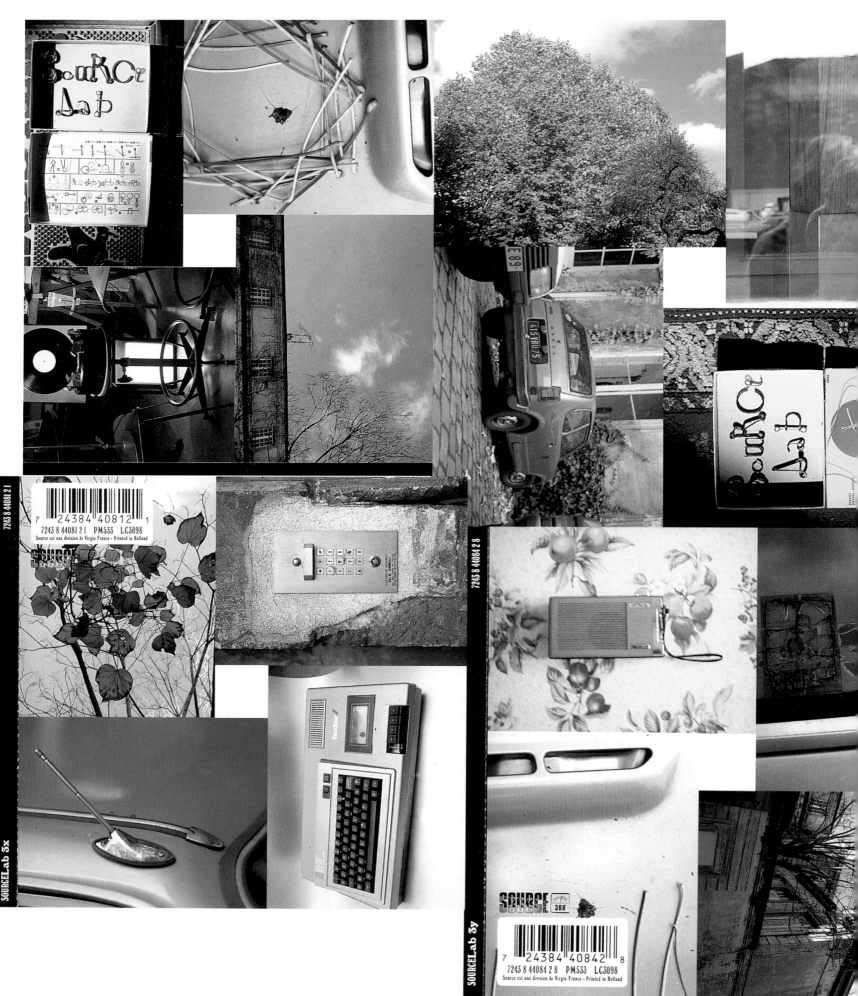

7243 8 7243 8
44081 44084
2 1 2 8

Various
Source Lab 3x/3y

CD fronts and reverse trays.
CD tray and booklet details (overleaf).

Design and photography:
Michael Amzalag &
Mathias Augusyniak
Source
1997

12 Jean-Jacques Perrey & Air 'Cosmic Bird'

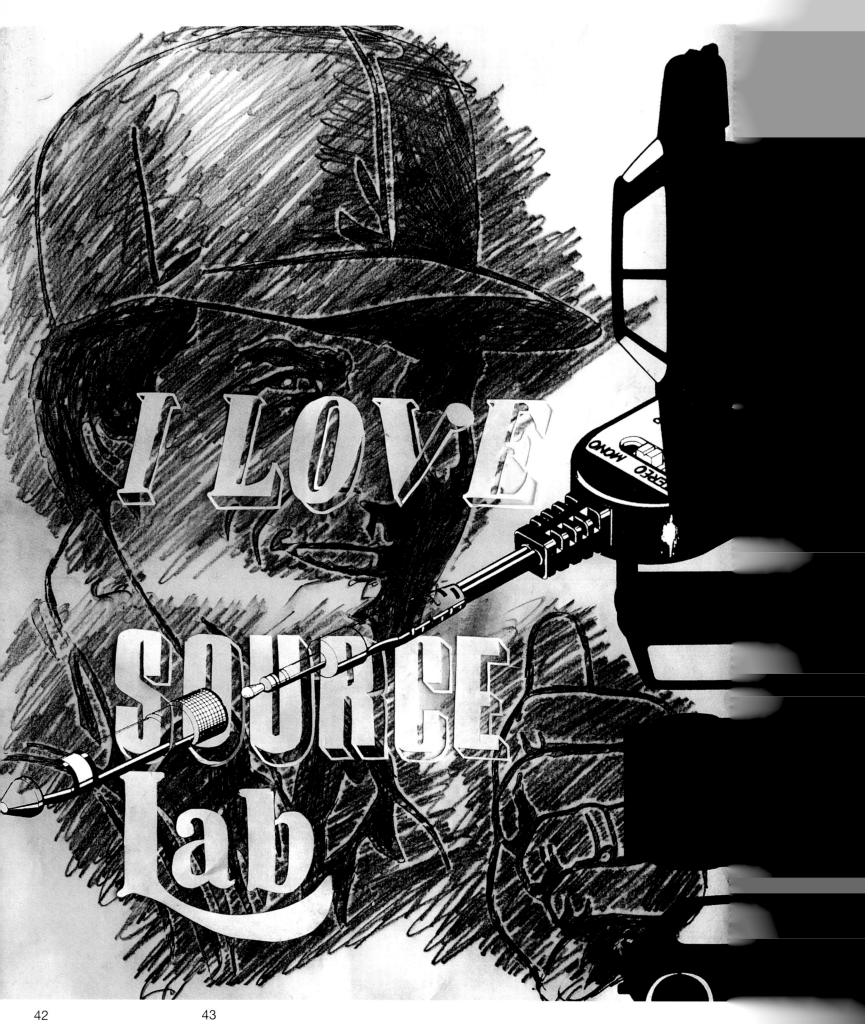

Tiger
Friends

Promo CD wallets.

Design: Stephen Male/
Latifah Cornelius @
Stephen Male Studios
Illustrations: Dan Laidler
Trade 2/Island
1998

TIGER

Friends Number two of a two part series

Friends
written by Tiger
produced by Stephen Street
engineered by Cenzo Townsend

**White Saab,
Dark Night**
written and produced by Fleas,
Laidler, Sims, Feeney, Goddard
engineered by Duncan Goddard
at Northern Echo

Rogue Robyn
written by Tiger
produced by Donald Ross Skinner
engineered & mixed
by Steve Musters

Starring Gavin Skinner (guest drummer) All titles: EMI Music Publishing Ltd

To Ray Neo-babe of spring

ends
n by Tiger
ced by Stephen Street

Wensleydale
written by Tiger
produced by Stephen Street

GR50 CD GR52 CD GR53 CD GB12 GR25 GR48 CD

Various
Camp SKiN GRAFT
Now Wave

Design: Mark Fischer
@ SKiN GRAFT Entertainment
SKiN GRAFT Records

Mount Shasta
Watch Out

Design: John Forbes,
Kurt Keisel, Mark Fischer
@ SKiN GRAFT Entertainment
Photography: Dawn Van Kampen
SKiN GRAFT Records

Zeek Scheck
Good Luck Suckers

Design: Rose Perkins Meyers
@ SKiN GRAFT/Turkey Entertainment
SKiN GRAFT Records

Various
Sides 1 – 4

Design: Mark Fischer
@ SKiN GRAFT Entertainment
SKiN GRAFT Records

Colossamite
Frisbee

Design: Mark Fischer
@ SKiN GRAFT Entertainment
SKiN GRAFT Records

Ketil Bjørnstad
David Darling
The River

CD slipcase and booklet spread.

Cover art: Mayo Bucher
Design: Detlev Riller
ECM
1997

Ketil Bjørnstad · David Darling

The River

ECM

ECM
1600/
01

ECM
1658

ECM
1639

Jean-Luc Godard
Nouvelle Vague

CD slipcase and booklet spread.

Design: Birgit Binner
Booklet images from the film
Nouvelle Vague by Jean-Luc Godard
ECM
1997

The Hilliard Ensemble
Lassus

CD slipcase.

Photography: Wolfgang Wiese
Design: Michael Hofstetter
ECM
1998

John Surman
Proverbs and Songs

CD slipcase.

Photography: Caroline Forbes
Design: Dieter Rehm
ECM
1997

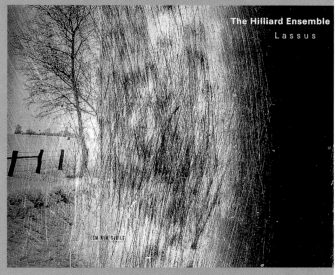

**JEAN-LUC GODARD
NOUVELLE VAGUE**

ECM NEW SERIES

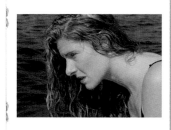

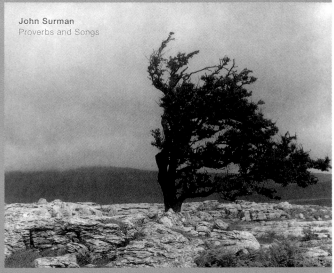

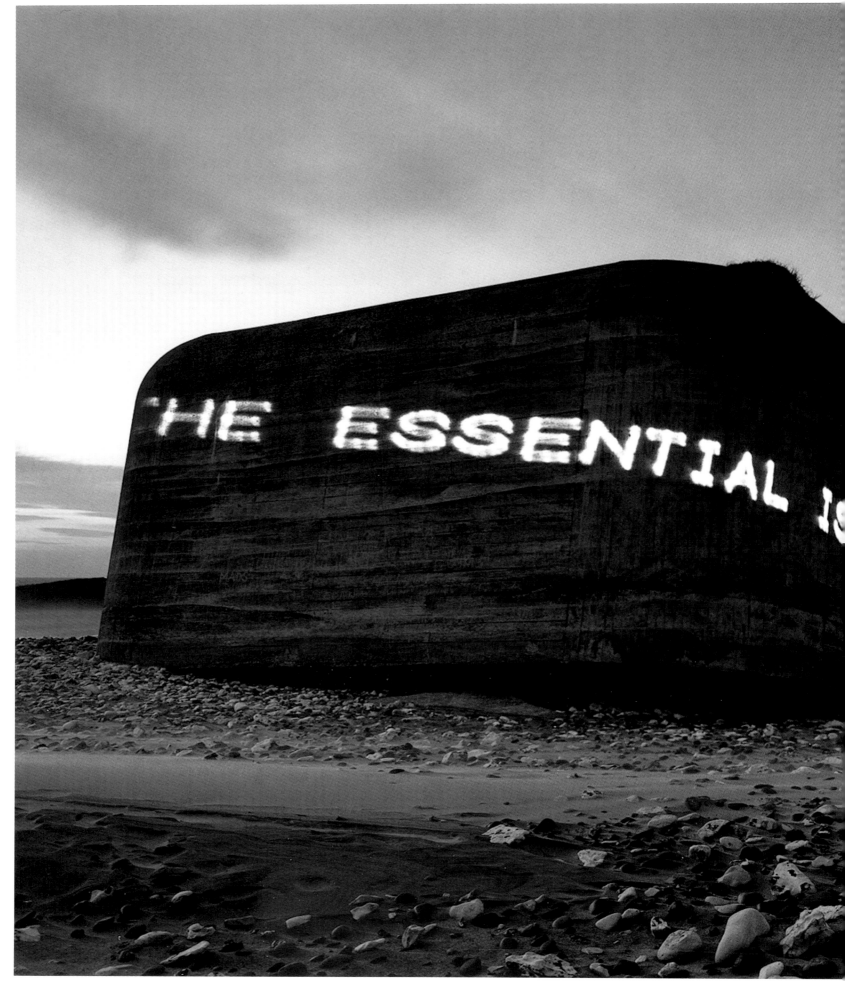

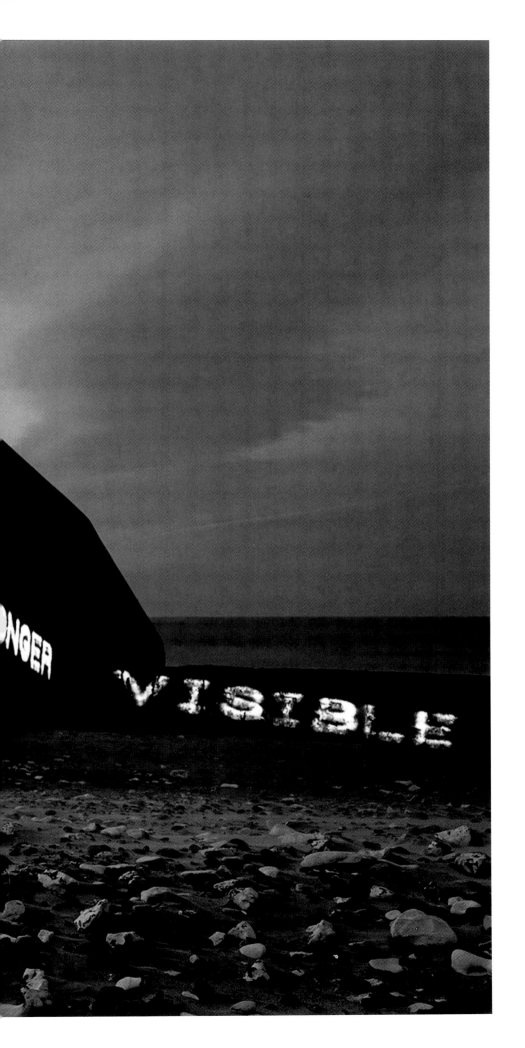

ECM
1650

Various
Selected Signs 1

The cover shows part of a 1995
installation by Magdalena Jetelová
entitled Atlantic Wall, photographed
by Werner J. Hannappel. This project
integrates quotes by Paul Virilio from
his book *Bunker Archaeology*.
ECM
1997

A.P.C.
003

A.P.C.
005

A.P.C. Tracks Vol. 1

CD packaging comprising jewel case
without booklet.

Design: Jean Touitou @ A.P.C.
A.P.C.
1996

Hiroshi Fujiwara
The A.P.C Experience

CD packaging comprising jewel case
without booklet.

Design: Rik Bas Backer @
Independant Graphist
A.P.C.
1997

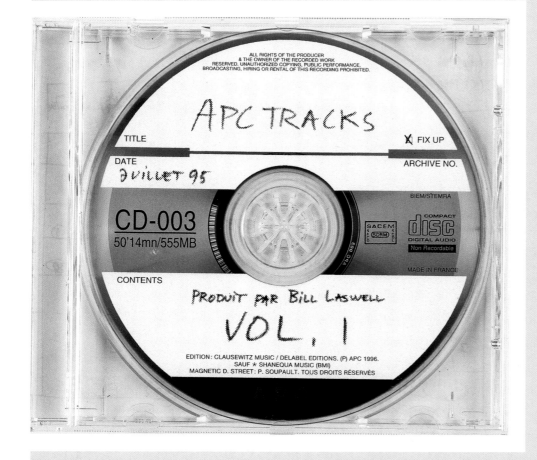

A.P.C.
004

A.P.C. Tracks Vol. 2

CD packaging comprising jewel case
without booklet.

Design: Jean Touitou @ A.P.C.
A.P.C.
1996

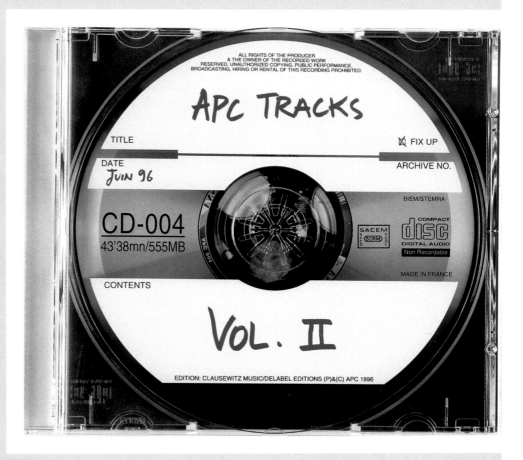

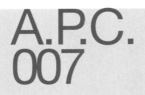

Various
The Unreleasable Tapes

CD reverse tray.

Design: Michael Amzalag
& Mathias Augustyniak @ M&M
A.P.C.
1997

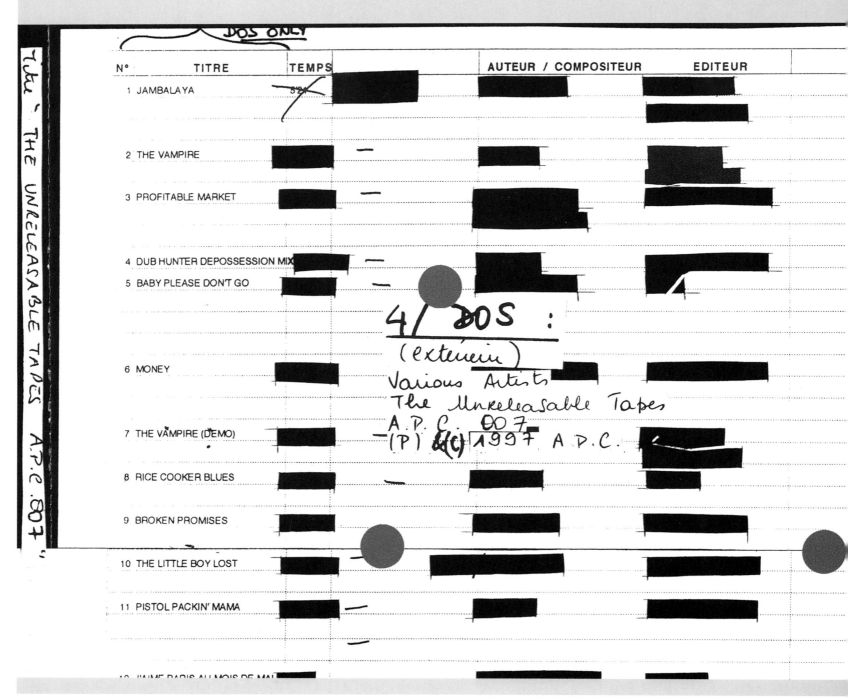

SYR 1 SYR 2 SYR 3

Sonic Youth
Perspectives Musicales

Sonic Youth
Muzikale Vergezichten

Sonic Youth/Jim O'Rourke
Muzikaj Perspektivoj

CD wallet.

Design: Sonic Youth/Christophe Habib
Sonic Youth Recordings
1997

CD wallet.

Design: Sonic Youth/Christophe Habib
Sonic Youth Recordings
1997

CD wallet.

Design: Sonic Youth/Christophe Habib
Sonic Youth Recordings
1997

Skeleton Key
Fantastic Spikes
Through Balloon

CD booklet with 5mm holes drilled
through all pages.

Design: Stefan Sagmeister/
Hjalti Karlsson @ Sagmeister Inc.
Photography: Tom Schierlitz
Capitol Records Inc.
1997

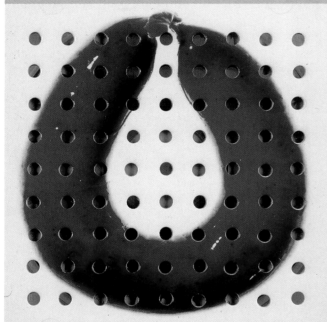

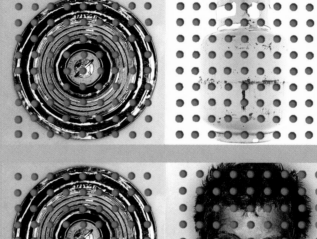

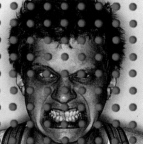

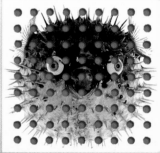

Paxton
Paxton

CD packaging with printed jewel case.

Packaging concept and design:
Stefan Sagmeister/Hjalti Karlsson
@ Sagmeister Inc.
Nemperor Records/Razor & Tie
1997

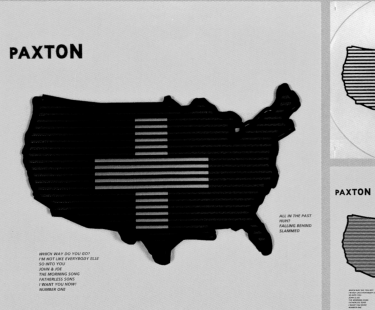

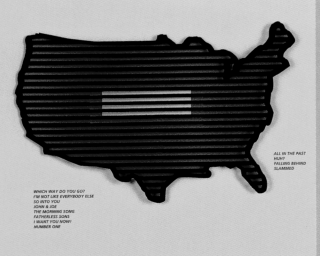

Mimi
Soak

CD booklet pages and label detail.

Design: Stefan Sagmeister/
Hjalti Karlsson @ Sagmeister Inc.
Photography: Carl May, Stock
Warner Brothers/Luka Bop
1998

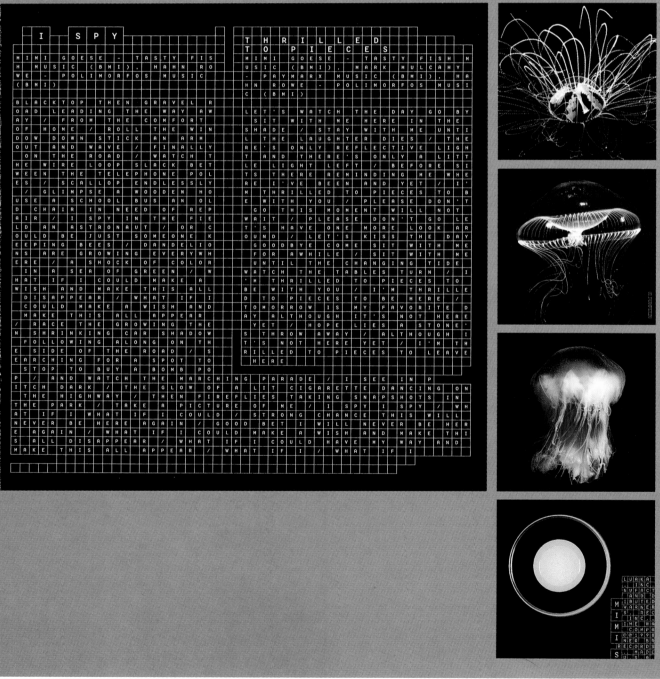

NRG
81107-
2

Pro-Pain
The Truth Hurts

CD booklet, inner tray and label.

Art direction and design:
Stefan Sagmeister/Veronica Oh
@ Sagmeister Inc.
Photography: Collection of the
Municipal Archives of the City
of New York
Energy Records
1994

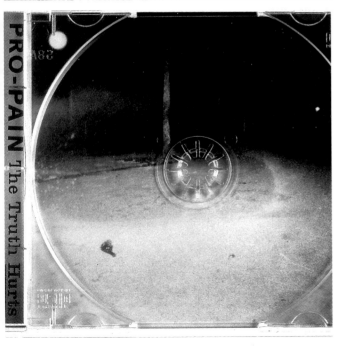

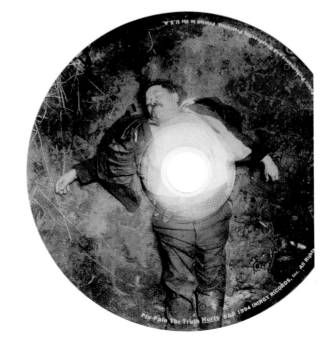

Teenage Fanclub
I Don't Want Control Of You

CD front.

Art direction: Mark Tappin
@ Blue Source
Photography: Donald Milne
(Bellshill)
Creation Records
1997

Teenage Fanclub
I Don't Want Control Of You

CD front.

Art direction: Mark Tappin
@ Blue Source
Photography: Donald Milne
(Waterloo)
Creation Records
1997

Teenage Fanclub
Ain't That Enough

CD front.

Art direction: Mark Tappin
@ Blue Source
Photography: Donald Milne
(Torness Nuclear Power Station)
Creation Records
1997

CreL7
224

CresL7
224/1

CresL7
224/3

Primal Scream
Echo Dek

7" boxfront, single and label.
Booklet spread (overleaf)

Design: House @ Intro
Creation Records
1997

Tortoise
TNT

CD inner sleeve, back and CD front.

Design: Tortoise
Layout assistance by Sheila Sachs
Drawing: John Herndon
Thrill Jockey
1998

tnt
swing from the gutters
~~gutters~~
ten-day interval
i set my face to the hillside
the equator
a simple way to go faster
than light that does not work
the suspension
bridge at iguazú falls
four-day interval
in sarah, menchen, christ,
and ~~beethoven~~ ~~beethor~~
beethoven ~~to~~ ~~beethoven~~
beethoven there were
women and men
almost always is nearly enough
jetty
everglade

TNT

INFOR-
MATION
Recorded, edited,
and mixed by John
McEntire at SOMA Electronic
Music Studios, with the
exception of "Ten-Day Interval" and
"Four-Day Interval," which were
recorded at Idful Music Corporation.
Recorded and mixed the year beginning
November 1996 and ending November
1997. Additional programming by Dan Bit-
ney and John Herndon. Mastered by Roger
Sebel at SAE Analog & Digital Mastering Ser-
vices. All titles composed by Tortoise, pub-
lished by Onions Wrapped in Rubber Music
(ASCAP). © 1998 Tortoise. ℗ 1998 Thrill Jockey.
Sleeve design by Tortoise; layout assistance by
Sheila Sachs. Performed by Tortoise with help
from Popahna Brandes (cello), Caitlin Horsmon
(bassoon), Julie Lu (violin), Rob Mazurek (cor-
net),and Sara P. Smith (trombone). Many thanks
to them, and also to Whitney Bradshaw •
Popahna Brandes • Christa Britton • Bundy K.
Brown • Geoff Caldwell • Andrew, Chris, Doug,
and Jerry at Cut-Rate • Christof Ellinghaus •
David Ellsworth • Dan Fliegel • Pat Foley •
Kathryn Frazier • Cathi Gibson • Richard Gra-
bel • Dara Greenwald • Howard Greynolds •
Ted Harris • Frank Karall • Noel Kilbride •
Miwa Kuroki • Damon Locks • Susanne
McCarthy • Brad Miller • Takafumi Ogi-
hara • Archer Prewitt • Casey Rice •
Jacqui Rice • Bettina Richards • Ben
Romans • Paul Romans • Sheila
Sachs • Berthold Seliger •
Gilberto Serna • LeRonda
Steen • Dee Tara • Corey,
Ed. Rick, and all at
Touch and Go •
Wyndham

Wallace • Alyson West •
Kiki Yablon • Tortoise is Dan Bitney, John Herndon,
Douglas McCombs, John McEntire, David
Pajo, and Jeff Parker. Tortoise proudly uses
Slingerland Drums.

INFORMATION
Enregistré, monté, et mixé par John McEntire à
SOMA Electronic Music Studios, à l'exception de
"Ten-Day Interval" et "Four-Day Interval," qui ont
été enregistrés à Idful Music Corporation. Enreg-
istré et mixé entre Novembre 1996 et Novembre
1997. Programmation supplémentaire par Dan
Bitney et John Herndon. Masterisé par Roger
Sebel à SAE Analog & Digital Mastering Services.
Titres composé par Tortoise, edité par Onions
Wrapped in Rubber Music (ASCAP). © 1998 Tor-
toise ℗ 1998 Thrill Jockey. Design par Tortoise,
conception-maquette par Sheila Sachs. interprété
par Tortoise avec l'ade de Popahna Brandes (vi-
oloncelle), Caitlin Horsmon (bassoon), Julie Lu (vi-
olon), Rob Mazurek (cornet), et Sara P. Smith
(trombone). Milles mercis à eux et aussi à Whit-
ney Bradshaw • Popahna Brandes • Christa Brit-
ton • Bundy K. Brown • Geoff Caldwell • Andrew,
Chris, Doug, et Jerry à Cut-Rate • Christof Elling-
haus • David Ellsworth • Dan Fliegel • Pat Foley •
Kathryn Frazier • Cathi Gibson • Richard Grabel •
Dara Greenwald • Howard Greynolds • Ted Har-
ris • Frank Karall • Noel Kilbride • Miwa Kuroki •
Damon Locks • Susanne McCarthy • Brad Miller
• Takafumi Ogihara • Archer Prewitt • Casey Rice
• Jacqui Rice • Bettina Richards • Ben Romans •
Paul Romans • Sheila Sachs • Berthold Seliger •
Gilberto Serna • LeRonda Steen • Dee Tara •
Corey, Ed. Rick, et tout le monde à Touch and Go
• Wyndham Wallace • Alyson West • Kiki Yablon
• Tortoise est Dan Bitney, John Herndon, Douglas
McCombs, John McEntire, David Pajo, et Jeff
Parker. Tortoise utilise Slingerland Drums avec fier.

INFORMACIONES
Grabado, editado, y mezclado por John McEntire
en SOMA Electronic Music Studios, con la ex-
cepción de "Ten-Day Interval" y "Four-Day Inter-
val," que fueron grabados en Idful Music

Corpora-
tion. Grabado,
y mezclado empe-
zando Noviembre
1996 y terminando en
Noviembre 1997. Progra-
mación adicional por Dan Bitney
y John Herndon. Masterizado por
Roger Sebel en SAE Analog & Digi-
tal Mastering Services. Todos los títulos
compuestos por Tortoise y publicados por
Onions Wrapped in Rubber Music (ASCAP).
© 1998 Tortoise. ℗ 1998 Thrill Jockey. Dis-
eño gráfico por Tortoise, asistente por Sheila
Sachs. Tocado por Tortoise con la ayuda de
Popahna Brandes (violoncelo), Caitlin Horsmon
(bajón), Julie Lu (violín), Rob Mazurek (corneta),
y Sara P. Smith (trombón). Muchisimas gracias
a ellos, y tambien a Whitney Bradshaw • Popahna
Brandes • Christa Britton • Bundy K. Brown •
Geoff Caldwell • Andrew, Chris, Doug, y Jerry at
Cut-Rate • Christof Ellinghaus • David Ellsworth •
Dan Fliegel • Pat Foley • Kathryn Frazier • Cathi
Gibson • Richard Grabel • Dara Greenwald •
Howard Greynolds • Ted Harris • Frank Karall •
Noel Kilbride • Miwa Kuroki • Damon Locks •
Susanne McCarthy • Brad Miller • Takafumi
Ogihara • Archer Prewitt • Casey Rice • Jacqui
Rice • Bettina Richards • Ben Romans • Paul
Romans • Sheila Sachs • Berthold Seliger •
Gilberto Serna • LeRonda Steen • Dee Tara
• Corey, Ed. Rick, y todos en Touch
and Go • Wyndham Wallace • Alyson
West • Kiki Yablon • Tortoise es Dan
Bitney, John Herndon, Douglas
McCombs, John McEntire, David
Pajo, y Jeff Parker. Tortoise
orgullosamente usa
Slingerland Drums.

CITY SLANG / EFA 08705 - 2
made in Germany under license from

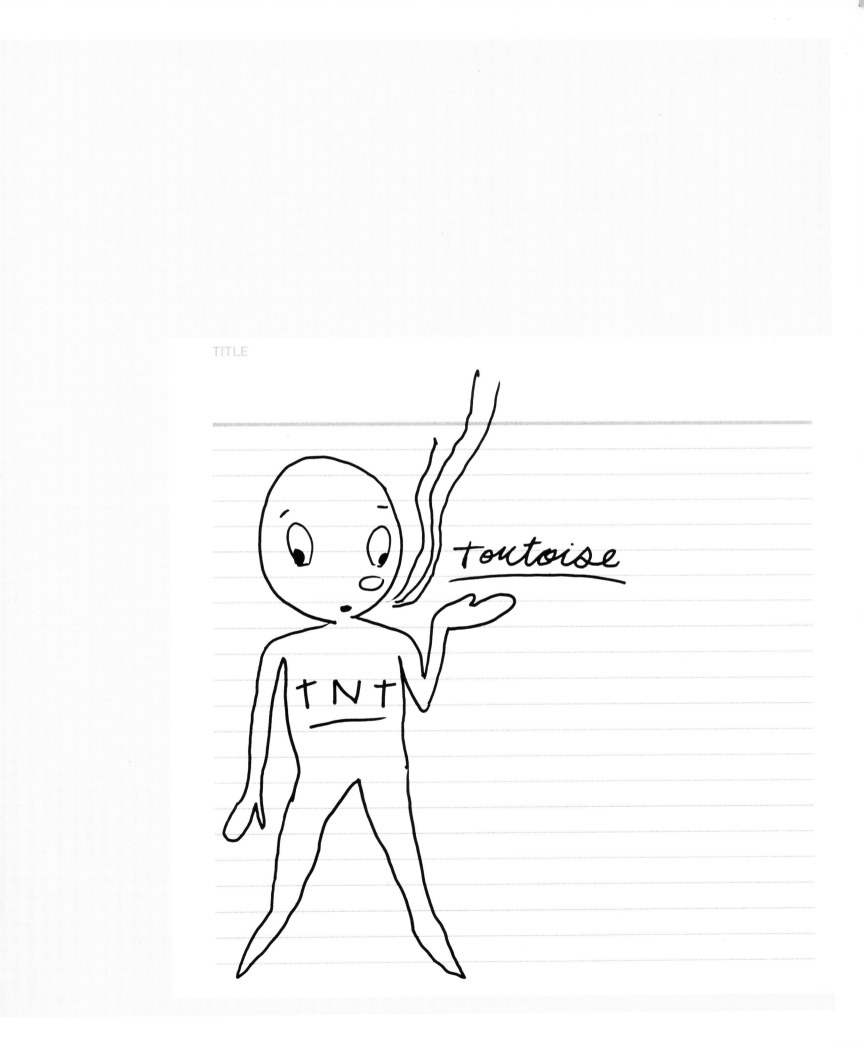

The Sea and Cake
The Fawn

12" front.

Design: Sam Prekop
Thrill Jockey
1997

the sea
and cake
the fawn

Rome
Rome

12" front and back.

Design: Richard Wakefield Smith
Photography: Michael Haye
Thrill Jockey

Disco Inferno
D.I. Go Pop

CD front.

Design: Miles Murray Sorrel Fuel
Photography: David Spero
Rough Trade Records
1994

Disco Inferno
Second Language EP

CD front.

Design: Miles Murray Sorrel Fuel
Photography: David Spero
Rough Trade Records
1994

Disco Inferno
The Last Dance EP

CD front.

Design: Miles Murray Sorrel Fuel
Photography: David Spero
Rough Trade Records
1993

MWO8
5DJ

UNKLE
Psyence Fiction Survival Kit

Printed box containing 12",
5" one track vinyl and stickers.
Campaign logos (bottom left).

Design: Ben Drury
Assisted by Andy Holmes
All characters originated by Futura 2000
UNKLE logo designed by Ben Drury
MoWax Recordings
1998

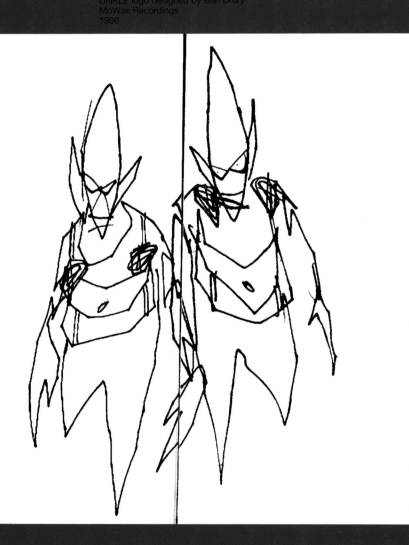

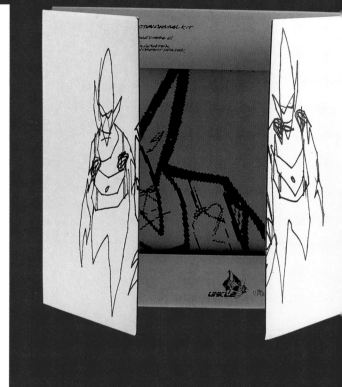

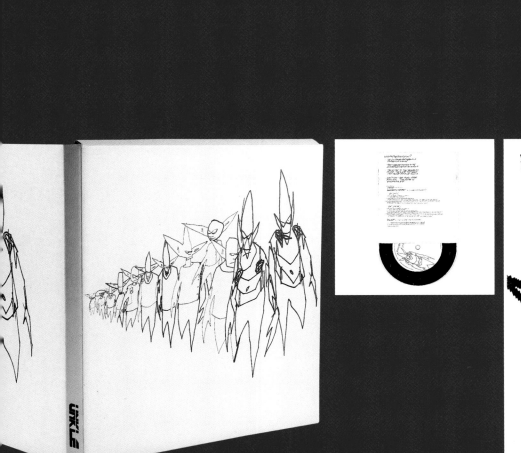

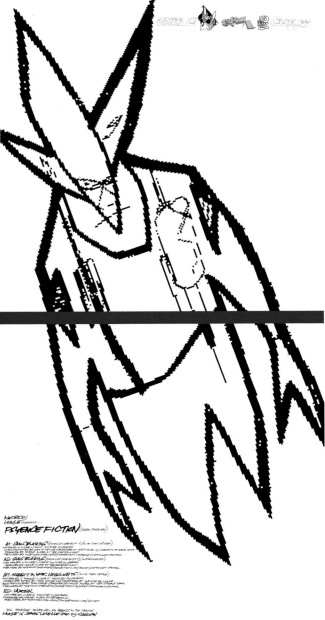

Money Mark
Push The Button

12" sleeve with rotational device and
die-cut window to view track listing.

Design: Ben Drury
Photography: Ben Drury (front cover)
Tamra Davis (portraits)
MoWax Recordings
1998

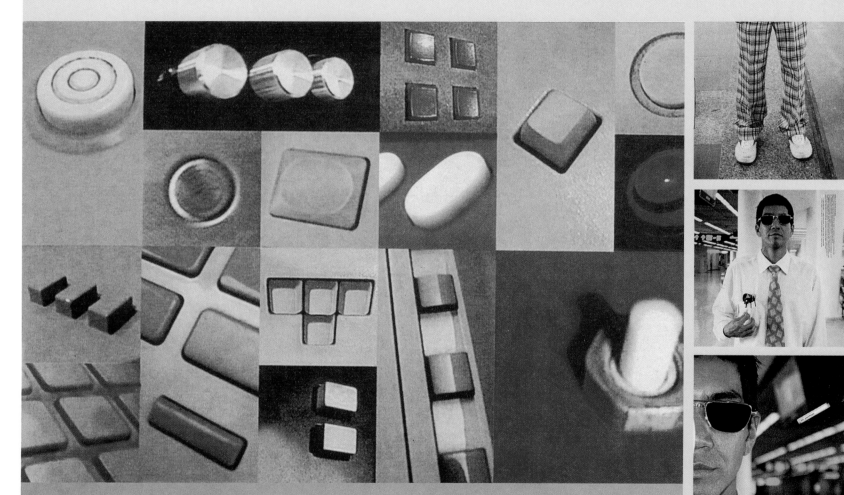

money mark
push the button

MWO7 8LP

Liquid Liquid
Liquid Liquid

12" sleeve featuring die-cut flap.

Design: Ben Drury
Photography: Ben Drury
Original Liquid Liquid sleeve by
Richard McGuire
MoWax Recordings
1997

SIDE A: 'OPTIMO' (1983)

OPTIMO
CAVERN
SCRAPER
OUT

SIDE B: 'SUCCESSIVE REFLEXES' (1981)

LOCK GROOVE (IN)
LOCK GROOVE (OUT)
PUSH
ZERO LEG
EYES SHARP

SIDE C: 'LIQUID LIQUID' (1981)

GROUPMEGROUP
NEW WALK
LUB DUPE
BELL HEAD
RUBBERMIRO

SIDE D: 'LIVE FROM BERKLEY SQUARE' (12TH MARCH 1982)

LOCK GROOVE (LIVE)
GROUPMEGROUP (LIVE)
BELL HEAD (LIVE)
PUSH (LIVE)

SCOTT HARTLEY - DRUMS, PERCUSSION, TALKING DRUM
RICHARD MCGUIRE - BASS, PERCUSSION, PIANO, ALARM BELL, GUITAR, MELODICA
SALVATORE PRINCIPATO - VOCALS, PERCUSSION
DENNIS YOUNG - MARIMBA, ROTO TOMS, PERCUSSION

WRITTEN BY LIQUID LIQUID
PUBLISHED BY LIQUID LIQUID PUBLISHING (BMI)
ALL TRANSFERS & DIGITAL EDITING BY PERKIN BARNES AT 6/8 STUDIOS
MANY THANKS TO SASHA FRERE-JONES

SIDE A. RECORDED & MIXED AT RADIO CITY STUDIO (NYC)
SIDE B. RECORDED & MIXED AT SORCERER SOUND (NYC)
ENGINEERED BY GREG CURRY & BRUCE TOVSKY
TRACK 2. WITH AL DIAZ - METALPHONES, GONZA & SAWBLADES & BILL KLEINSMITH - BERIMBAU
TRACK 5. WITH ELLIOT SHARP - BASS CLARINET
SIDE C. TRACK 1. RECORDED AT MANMADE STUDIOS, MIXED AT SORCERER SOUND
WITH BILL KLEINSMITH - CONGAS
TRACKS. 2, 3 & 4, RECORDED AT HURRAHS NYC (LIVE) 13TH FEBRUARY 1981
TRACK 5. RECORDED AT NOISE N.Y, MIXED AT SORCERER SOUND.
WITH AL DIAZ - METALPHONES, RICHARD EDSON - TRUMPET
SIDE D. RECORDED AT BERKLEY SQUARE (LIVE) MARCH 12TH 1982
DIGITAL RESTORATION BY BRUCE TOVSKY & JIM HEFFERMAN AT NVI

MW078LP

SLEEVE DESIGN : BEN DRURY
ORIGINAL ARTWORK : RICHARD McGUIRE
INTERNATIONAL A&R : JAMES LAVELLE

THIS COMPILATION :
(P) 1997 MOWAX RECORDINGS/A&M RECORDS LTD. LONDON
(C) 1997 MOWAX RECORDINGS/A&M RECORDS LTD. LONDON
MADE IN ENGLAND BIEM MCPS

Pan-Sonic
Arctic Rangers

'Self Assembly Analogue
Soundscape Set'
2 X 7" singles, decals and instructions.
One 7" contains beats, the other
electronic tones. The instructions
demonstrate how to combine these
with a set of turntables.

Design: Robert Green
Blast First
1998

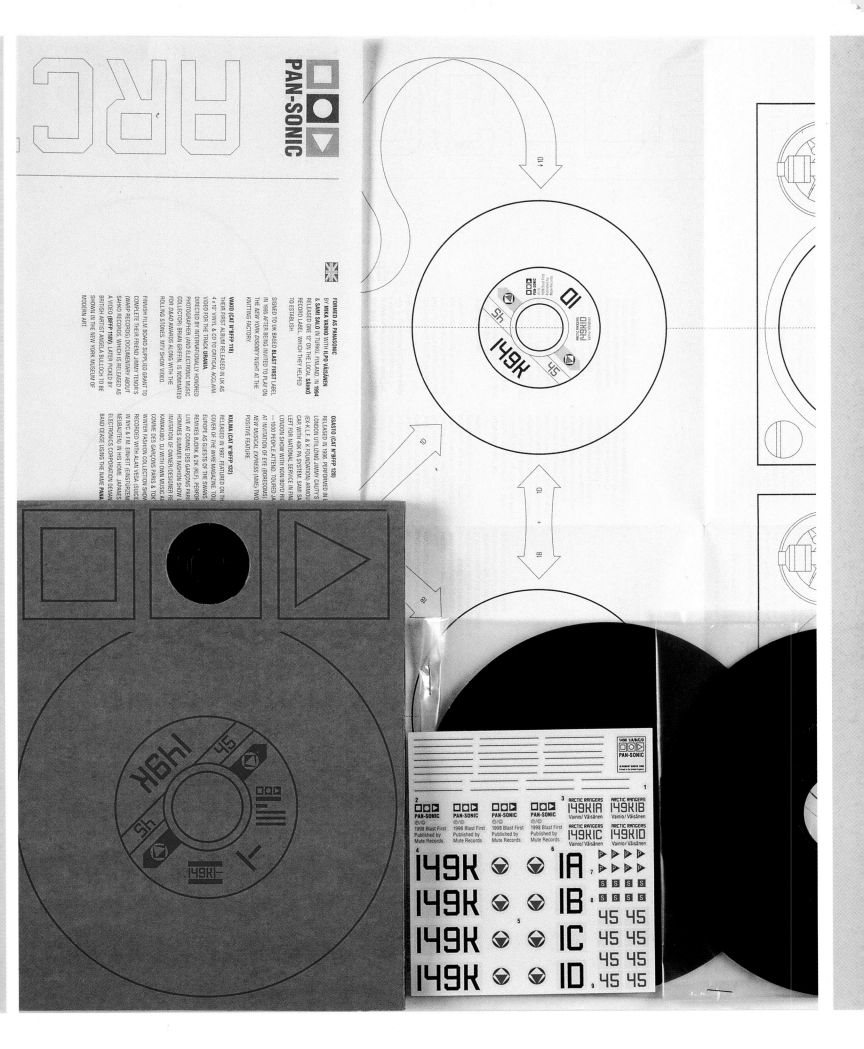

Panasonic
Osasto EP

CD front, back and label.

Design: Russell Haswell
Blast First
1996

Panasonic
Vakio

CD packaging with typography
printed in blue on clear wallet.

Design: Ilpo Väisänen and
A. Men Architects/TG
Blast First
1996

SOLID
SCD6

Various
Hip Hop Don't Stop

CD front, back and inner wallet.

Design: Peter Chadwick @ Zip Design
Illustration: Will Barras
Solid State Records
1997

SOLID
LP16

Various
Hip Hop Don't Stop 3

12" inner bag detail.

Design: Peter Chadwick @ Zip Design
Illustration: Will Barras
Solid State Records
1998

THANKS TO ALL AT SOLID STATE RECORDS

LICENSING RESPECT GOING OUT TO KAREN @ POLYGRAM. ELLIE @ EMI. ANN @ VIRGIN. ALAN & LUCY @ SONY. TONYA (& KATHY) @ WARNERS.
KATIE & PAUL @ BMG. TINA & ROSEANNE @ JIVE. ALAN & JOHN @ PROFILE. KERRY & JIM @ TOMMY BOY. FRED @ SELECT. JEFF @ TUFF CITY.
ANDREA @ PRIORITY. CARL @ REALITY. MICHELLE @ WARLOCK.

DIGITAL MASTERING BY DICK BEETHAM @ TAPE II TAPE. SLEEVE/ART DIRECTION BY ZIP DESIGN. ILLUSTRATIONS WILL 'THE PRINCE' BARRAS

ZEN317
1&2

DJ Vadim
Re Construction
Theories Explained

12" sleeve and CD booklet details.

Design: Kevin Foakes @ Openmind
Photography: Nancy Brown
Ninja Tune
1997

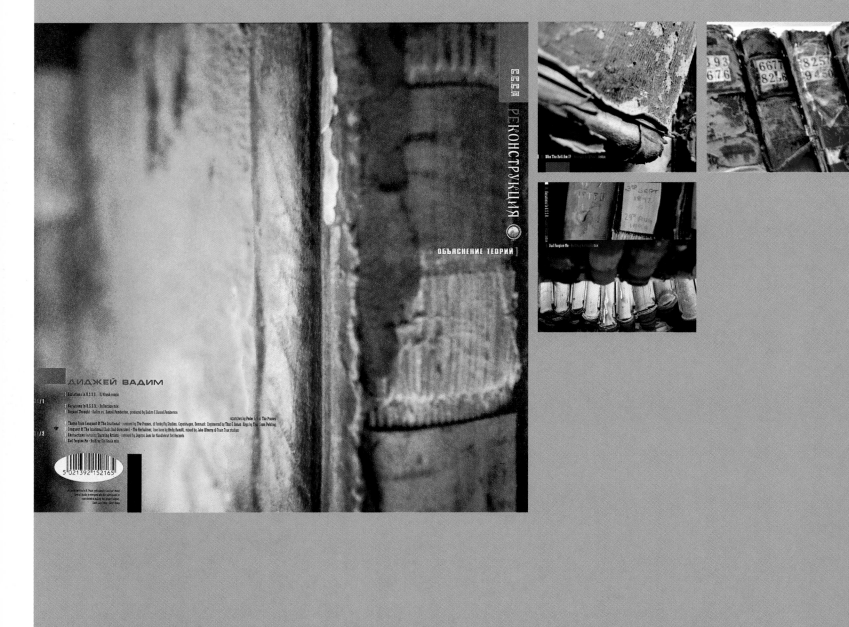

soul 16

circadia

soul static sound

thanx : darryl + kevin p + k.martin : luv to uka : recorded and mixed at berry st. studios, london

packaging by wright / wilkinson

made in england

soul
16

soul
21.2

soul
21.1

soul
19

Eardrum
First Mutations

Ganger
Trilogy. Two Lone
Swordsmen

Ganger
Trilogy. d

Him
Changes. The Focus

12" cover (previous page).

Design and photography:
R.K.Wilkinson & Ian Wright
@ Wilkinson Wright
Soul Static Sound

12" front.

Design and photography:
R.K.Wilkinson & Ian Wright
@ Wilkinson Wright
Soul Static Sound

12" front.

Design and photography:
R.K.Wilkinson & Ian Wright
@ Wilkinson Wright
Soul Static Sound

12" front.

Design and photography:
R.K.Wilkinson & Ian Wright
@ Wilkinson Wright
Soul Static Sound

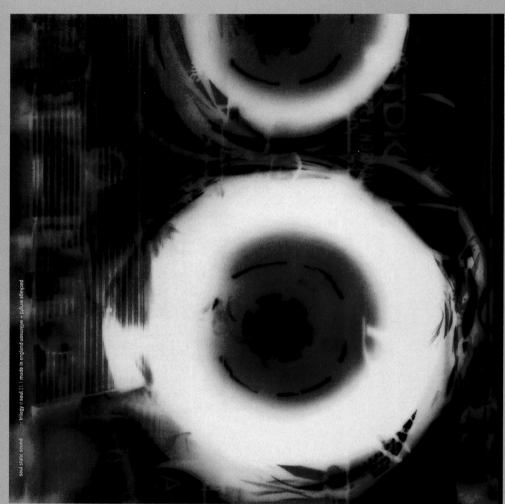

him : the focus

changes

christian dautresme : **vocals, binghi drum**
curtis harvey : **flutes** (zamfier style)
sasha frere jones : **bass**
dawn mccarthy : **vocals**
doug scharin : **drums, clay drum, kalimbas, marimba, percussion**
amanda reisman : **cello**

ian frazer : **guitar**
fred erskine : **bass**
doug scharin : **drums, samples, dumbek**

soul 19
made in england

packaging ÷ wilkinson/wright

Fridge
Anglepoised

12" front with title/barcode cropped
on edge, type continues inside sleeve.

Design: Trevor Jackson
Output Recordings
1997

**OPR
15D**

Fridge
Limited Edition
Two Record Set

12" and 7" in plastic bag.
All track information and other
details printed on bag.

Design: Trevor Jackson
Output Recordings
1998

Fridge
Sevens And Twelves

Screenprinted CD jewel case.

Design: Trevor Jackson
Output Recordings
1998

Fridge
Ceefax

Blank CD jewel case with title printed
on outer plastic bag. Includes 12 page
blank CD booklet. (Opposite) blank
CD reverse tray. All information
appears on the spine.

Design: Trevor Jackson
Output Recordings
1997

OPRCD6 FRIDGE CEEFAX 1. EDM 2. HELICOPTER 3. TRICITY 4. MORE EH4-800 5. JAZZ LOOP 6. ROBOTS IN DISGUISE 7. EDM 2 8. ORACLE 9. EDM3 10. ZED EX AY-TI-WAN

Written, Performed and Produced by Fridge in Sams Room. Flute on Robots in Disguise by Kate. ℗ + © 1997 Output Recordings Ltd. Distributed by RTM. Made in England. Input to: 13-15 Vine Hill London EC1R 5DX Telephone 0171 916 1569 Fax 0171 916 1570

OUTPUT

ISOM
11SMS

Travis
More Than Us EP

CD front and 120mm square cards.

Design: Martin Tappin @ Blue Source
Photography: Bridgette Smith
Independiente
1998

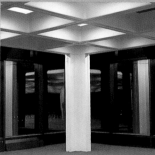

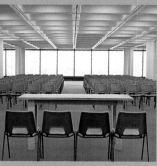

CID
8064

Puressence
Only Forever

CD front and booklet inner spreads
(this page and overleaf).

Design: Danny Doyle @ Blue Source
Photography: Nick Waplington
Island Records
1998

PURESSENCE ONLY FOREVER

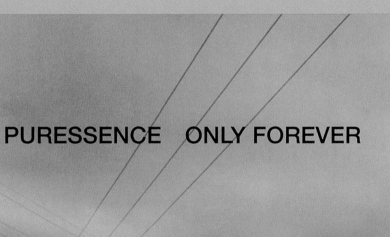

Massive Attack
Teardrop

CD single front and back.

Design: Tom Hingston
& Robert Del Naja
Photography: Nick Knight
Circa Records
1998

Massive Attack
Angel

CD single front and back.

Design: Tom Hingston
& Robert Del Naja
Photography: Nick Knight
Circa Records
1998

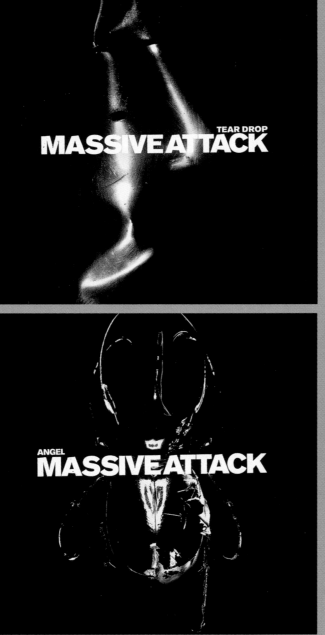

01 Teardrop (LP Version) 5.29 02 Euro Zero
Zero* 4.22 03 Teardrop (Scream Team Remix)
6.43 Additional production and remix by
Brendan Lynch for Lynch Mob Productions
04 Teardrop (Mad Professor Mazaruni
Instrumental Mix) 6.24 Remixed by Mad
Professor. All tracks written by Del Naja,
Marshall, Vowles, Fraser, and published by
Island Music Ltd/Sony Music Publishing,
except:* Written by Del Naja, Marshall, Vowles
Tricky, Norfolk, Locke. Published by Island
Music Ltd/ Copyright control. All tracks
produced and arranged by Massive Attack
and Neil Davidge. Mixed by Mark 'Spike'
Stent. The copyright in this recording owned
by Circa Records Ltd.

01 Angel 6.18 Mixed by Mark 'Spike' Stent,
assisted by Jan Kybert and P-Dub. 02 Angel
(Remix) 6.20 Remixed by Damon Albarn and
Graham Coxon of Blur. 03 Group Four* (Mad
Professor Remix) 5.00 Remixed by The Mad
Professor. All tracks written by Del Naja,
Marshall, Vowles, Hinds. Published by Island
Music Ltd/BMG Publishing Ltd, except:*
Written by Del Naja, Marshall, Vowles, Fraser.
Published by Island Music Ltd/Sony Music
Publishing. Produced and arranged by Massive
Attack and Neil Davidge. Recorded at Massive
Attack and Christchurch Studios, Bristol. The
copyright in this recording is owned by Circa
Records Ltd.

WBR CDJ11 WBR CDJ9

Massive Attack
Inertia Creeps

Promo CD single front and back.

Design: Tom Hingston
& Robert Del Naja
Circa Records
1998

Massive Attack
Teardrop

Promo CD single front and back.

Design: Tom Hingston
& Robert Del Naja
Circa Records
1998

01 Inertia Creeps/Radio Edit 4.09 02 Inertia Creeps/Manic Street Preachers Version 5.01 Remixed for Valley Boy Productions. Engineered by Dave Eringa. Assisted by Paul Hicks. All Tracks written by Del Naja, Marshall, Vowles. Produced and arranged by Massive Attack and Neil Davidge. Mixed by Mark 'Spike' Stent. Published by Island Music Ltd. The Copyright in this recording is owned by Circa Records Ltd. Promo use only: Not for resale. WBRCDJ11

MASSIVE ATTACK
INERTIA CREEPS

01 Teardrop (Edit) 4.40 02 Teardrop (LP Version) 5.29 Written by Del Naja, Marshall, Vowles, Fraser. Produced and arranged by Massive Attack and Neil Davidge. Published by Island Music Ltd/Sony Music Publishing. The copyright in this recording is owned by Circa Records Ltd. Promo use only: Not for resale. WBRXDJ9

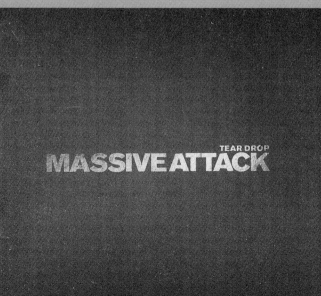

MASSIVE ATTACK TEAR DROP

Faze Action
Plans + Designs

12" front, back and inner sleeve
with disc.

Design: Tom Hingston
@ Tom Hingston Studio
Nuphonic
1998

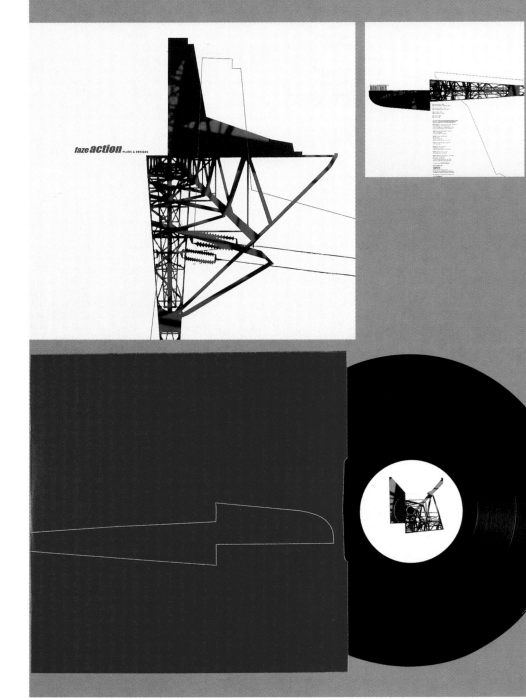

NUX NUX
118CD 122CD

Various
Spiritual Life Music

Various
Nuphonic 01

CD front and fold-out inner.

CD front.

Design: Tom Hingston
Photography: Alison Walker
@ Tom Hingston Studio
Nuphonic
1998

Design: Tom Hingston
@ Tom Hingston Studio
Nuphonic
1998

Spiritual Life Music

NUPHONIC 01
BLAZE: MOONWALK 6.57, KERRI
CHANDLER & JOE CLAUSSELL:
ESCRAVOS DE JO 7.23, YELLOW SOX:
FLIM FLAM 8.17, FREE CHICAGO
MOVEMENT: RECOGNIZE 7.00, SOUL
ACSCENDANTS: TRIBUTE 3.48, BLACK
JAZZ CHRONICLES: SNOOKY'S SPIRIT
3.41, FAZE ACTION: IN THE TREES
7.33, TEN CITY: NOTHING'S CHANGED
6.12, FUZZ AGAINST JUNK: COUNTRY
CLONK 10.23, TOTAL MUSIC TIME
67.17 CAT. NO. NUX122

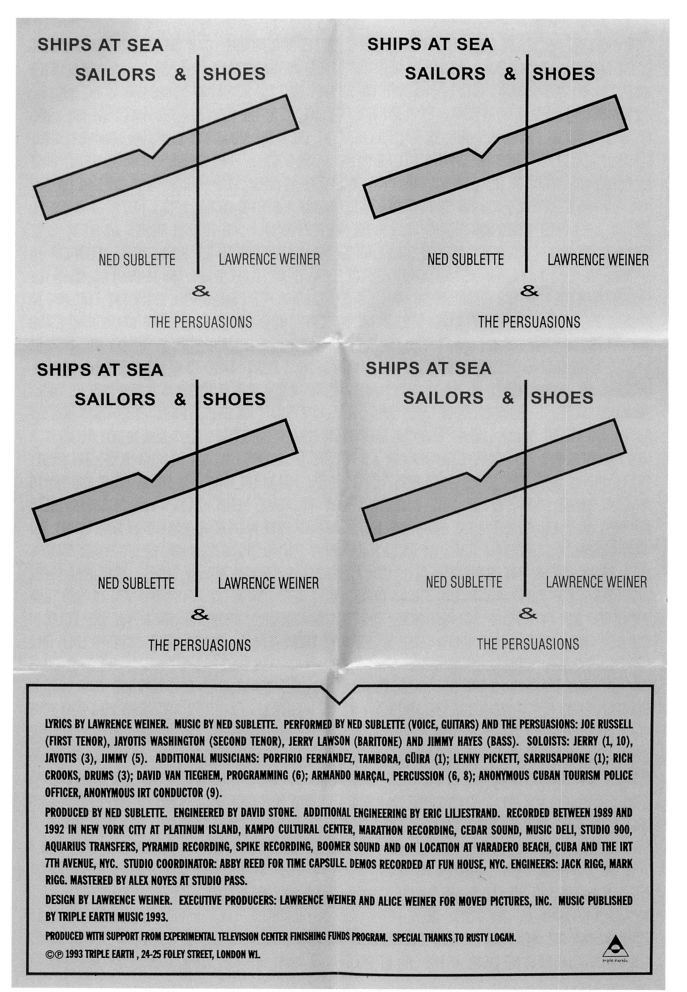

LYRICS BY LAWRENCE WEINER. MUSIC BY NED SUBLETTE. PERFORMED BY NED SUBLETTE (VOICE, GUITARS) AND THE PERSUASIONS: JOE RUSSELL (FIRST TENOR), JAYOTIS WASHINGTON (SECOND TENOR), JERRY LAWSON (BARITONE) AND JIMMY HAYES (BASS). SOLOISTS: JERRY (1, 10), JAYOTIS (3), JIMMY (5). ADDITIONAL MUSICIANS: PORFIRIO FERNANDEZ, TAMBORA, GÜIRA (1); LENNY PICKETT, SARRUSAPHONE (1); RICH CROOKS, DRUMS (3); DAVID VAN TIEGHEM, PROGRAMMING (6); ARMANDO MARÇAL, PERCUSSION (6, 8); ANONYMOUS CUBAN TOURISM POLICE OFFICER, ANONYMOUS IRT CONDUCTOR (9).

PRODUCED BY NED SUBLETTE. ENGINEERED BY DAVID STONE. ADDITIONAL ENGINEERING BY ERIC LILJESTRAND. RECORDED BETWEEN 1989 AND 1992 IN NEW YORK CITY AT PLATINUM ISLAND, KAMPO CULTURAL CENTER, MARATHON RECORDING, CEDAR SOUND, MUSIC DELI, STUDIO 900, AQUARIUS TRANSFERS, PYRAMID RECORDING, SPIKE RECORDING, BOOMER SOUND AND ON LOCATION AT VARADERO BEACH, CUBA AND THE IRT 7TH AVENUE, NYC. STUDIO COORDINATOR: ABBY REED FOR TIME CAPSULE. DEMOS RECORDED AT FUN HOUSE, NYC. ENGINEERS: JACK RIGG, MARK RIGG. MASTERED BY ALEX NOYES AT STUDIO PASS.

DESIGN BY LAWRENCE WEINER. EXECUTIVE PRODUCERS: LAWRENCE WEINER AND ALICE WEINER FOR MOVED PICTURES, INC. MUSIC PUBLISHED BY TRIPLE EARTH MUSIC 1993.

PRODUCED WITH SUPPORT FROM EXPERIMENTAL TELEVISION CENTER FINISHING FUNDS PROGRAM. SPECIAL THANKS TO RUSTY LOGAN.

©℗ 1993 TRIPLE EARTH , 24-25 FOLEY STREET, LONDON W1.

IN THE ROCKS... EVER WIDENING CIRCLES OF REMORSE AFLOAT AT THE MERCY OF THE WAVE
JUDGED BY HER POSSESSIONS I FIND I HAVE WATER IN MY EYES DAM THE RIVER START THROV
EVER WIDENING CIRCLES OF REMORSE ET IN ARCADIA EGO AFLOAT AT THE MERCY OF THE V
AT SEA NOT DUCKS ON A POND THEY'RE SWEEPING OUT THE BARS THE SHARDS OF GLASS
FLESH UPON OUR FEET DAM THE RIVER START THROWING IN THE ROCKS... EVER WIDENING (
AFLOAT AT THE MERCY OF THE WAVES I FIND I HAVE WATER IN MY EYES STARS DON'T STA
ONE FOR THE MONEY TWO FOR THE SHOW THREE TO GET READY AND FOUR TO GO ROUND
AROUND THE WORLD STARS DON'T STAND STILL IN THE SKY FOR ANYBODY ONE FOR THE MOI
TWO FOR THE SHOW IT'S TOUCH AND GO THREE TO GET READY AND FOUR TO GO ROUND
AROUND THE WORLD ONE FOR THE MONEY TWO FOR THE SHOW THREE TO GET READY AND FC
SAILOR GIVEN THE SHIP IT'S TOUCH AND GO WE FLY BY NIGHT STARS DON'T STAND STILL IN T
AROUND THE WORLD STARS DON'T STAND STILL IN THE SKY GIVEN THE SAILOR GIVEN THE SHIF
STILL IN THE SKY ONE FOR THE MONEY TWO FOR THE SHOW STARS DON'T STAND STILL IN T
A NEW PAIR OF SHOES WE WENT HOME & IN THE MANNER OF MOST PEOPLE TRIED TO HAVE S
ING LOVE NO WORRY NEEDED ON MY BEHALF SOMETIMES ALL A GIRL REALLY NEEDS IS A
SOMETIMES BEEN IN LOS ANGELES OF LATE LIVING OUT MY FATE SHALL WE DRESS FOR DINI
SOUND LIKE WE DO SOUND LIKE NO WORRY NEEDED ON MY BEHALF SOMETIMES ALL A GIRI
NEW PAIR OF SHOES IN PASSING A BRAIN A GIRL & A TYPEWRITER & YOU'RE ALL SET TO MAK
THE EGYPTIANS MUST HAVE UNDERSTOOD PERSPECTIVE HAVING FUN IN THE DARK WE DID (
HAVE SEX WE DID END UP MAKING LOVE SOMETIMES ALL A GIRL REALLY NEEDS IS A NEW P/
INTEREST WILL LEAD TO HAPPINESS YOUR TIME IS OUR TIME & YOU'RE ALL SET TO MAKE &
WORRY NEEDED ON MY BEHALF SHALL WE DRESS FOR DINNER? HAVING FUN IN THE DARK WE
LOVE LIVING OUT MY FATE SOMETIMES ALL A GIRL REALLY NEEDS IS A NEW PAIR OF SHOES
JUST OVER THERE POLES IN THE CLAY STONES ON THE POLES STANDING IN THE WATER ON
THE OTHER JUST OVER THERE NOT OVER HERE FIND THE STAR (POLARIS) KNOW NOT WHER
THE CLAY WITH THE CURRENT GENTLY SWAYING JUST OVER THERE LARGE WIND COMES
POLES IN THE CLAY STONES IN THE WATER POLES IN THE CLAY STANDING IN THE WATEI
FIND THE STAR (POLARIS) KNOW NOT WHERE YOU ARE BIG BANG/NEW FLORA ROW ROV
THE SHIT FLOWS GENTLY DOWN THE STREAM HEAVY METALS VALIUM LEAD & OTHER TOYS I
BOAT WHAT WE DON'T FLUSH AWAY WILL BLOW AWAY ANOTHER DAY BIG BANG CHANGE O
STATE CHANGE THE VALUE ROW ROW ROW YOUR BOAT SHIT FLOATS TO THE SURFACE HEAVY
& OTHER TOYS BIG BANG CHANGE OF STATE CHANGE OF STATE BIG BANG CAPTAIN OF A SHII
GENTLY DOWN THE STREAM ROW ROW ROW YOUR BOAT ROW ROW ROW YOUR BOAT WHAT W

TRECD
112

Ned Sublette, Lawrence Weiner
& The Persuasions
Ships at Sea, Sailors & Shoes

Fold-out CD booklet.

Design: Lawrence Weiner
Triple Earth/Excellent
1993

UP02

UP07 UP09

Unknown Public
Common Ground

Boxed CD, cassette and loose leaves.

Design: John Warwicker,
Graham Wood @ Tomato
Photography: Andy Goldsworthy
Additional page design by
Michelle Ashenden
Unknown Public
1993

Unknown Public
The Netherlands
Connection

Boxed CD, booklet, cassette and
random postcard.
(Opposite) booklet cover.

Design: Jason Kedgley &
John Warwicker @ Tomato
Unknown Public
1996

Unknown Public
All Seeing Ear

Boxed CD or cassette, 2 fold-out
pages and booklet.

Design: Richard Hollis
Original logo by John Warwicker
@ Tomato
Unknown Public
1997

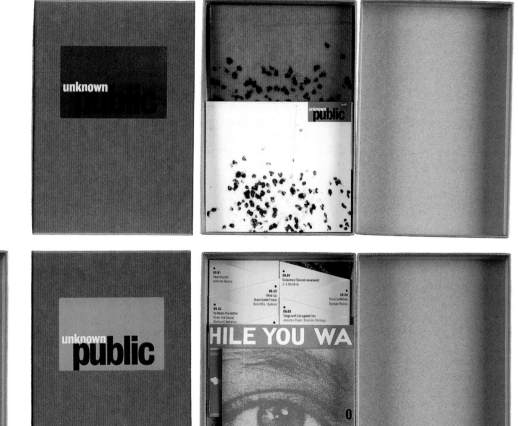

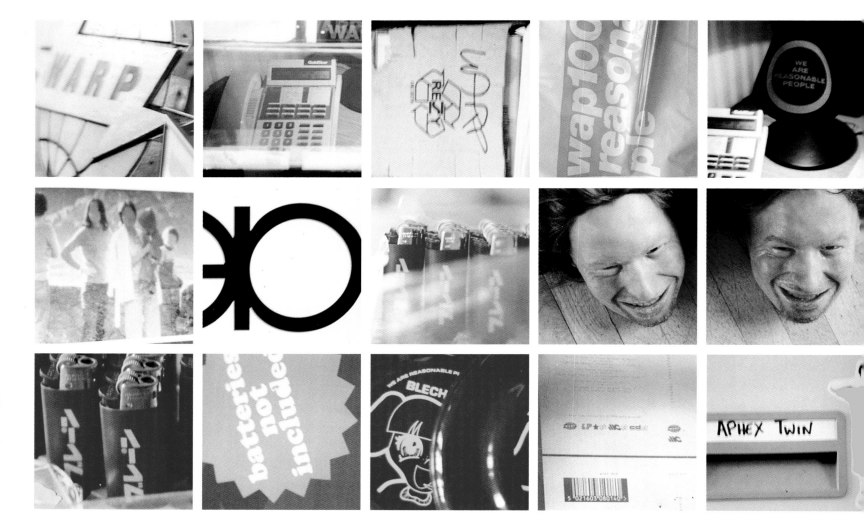

WARP S1 3BW

Warp Records
Sheffield

'The office ambience.'

WAP
94CDR

Aphex Twin
Come To Daddy Remixed

CD booklet front, back and
CD reverse tray.

Design: The Designers Republic
Warp Records
1997

WAP94CDR Sampling Frequency 44.1kHz
Quantizing Timing: Concurrent for all channels
Individual Track Time

01.5 mins 10 secs 22 frames.
02.3 mins 55 secs 60 frames.

03.4 mins 20 secs 27 frames.
04.3 mins 00 secs 01 frames.

Total Playing Time
16 mins 23secs 19 frames.

An image of children chasing after an ice-cream van from an Orange™ TV commercial advertising Text Messaging.

Aphex Twin.
Commercial Item.
As heard on the
Orange™ TV ad.
Remix.
WAP94CD.
LC2070.
Barcode. 5021603094086.

In the future people will think it strange that we only ever used the phone to talk to one another.
SUPER.
Work Together.

WAP 94CDX

Aphex Twin
Come To Daddy

CD booklet front, back and
CD inner tray.

Design: The Designers Republic
Warp Records
1997

Aphex Twin, Come To Daddy.

WAP 94CDX.
Sampling Frequency 44.1kHz

Individual Track Times.
Signal area:
50 mm - 116 mm

01. 4 mins 23 secs.
02. 2 mins 57 secs.
03. 3 mins 48 secs.

04. 5 mins 45 secs.
05. 5 mins 10 secs.

06. 3 mins 55 secs.
07. 4 mins 24 secs.
08. 3 mins 03 secs.

Reproduced By Kind Permission
of Chrysalis Music.

I Want Your Soul,
I Will Eat Your Soul.
I Want Your Soul,
I Will Eat Your Soul.
I Want Your Soul,
I Will Eat Your Soul.
I Want Your Soul,
I Will Eat Your Soul.

COME TO DADDY.
Repeat x 7.
Come To Mummy.
Repeat Line 1 x 3.
Aargh.

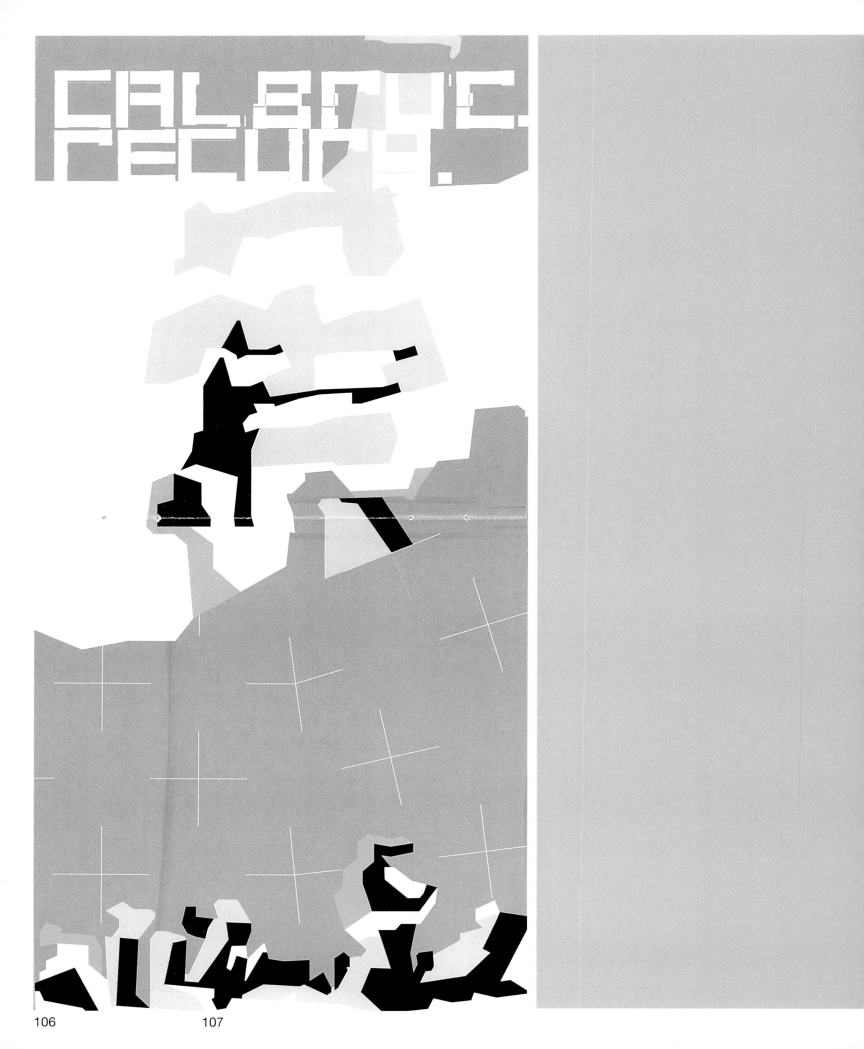

WARP
CD49

wap
96cd

Autechre
Chiastic Slide

CD front and reverse tray.
(Opposite) CD booklet spread.

Design: The Designers Republic
Warp Records
1997

Autechre
Cichlisuite

CD front and reverse tray.

Design: The Designers Republic
Warp Records
1997

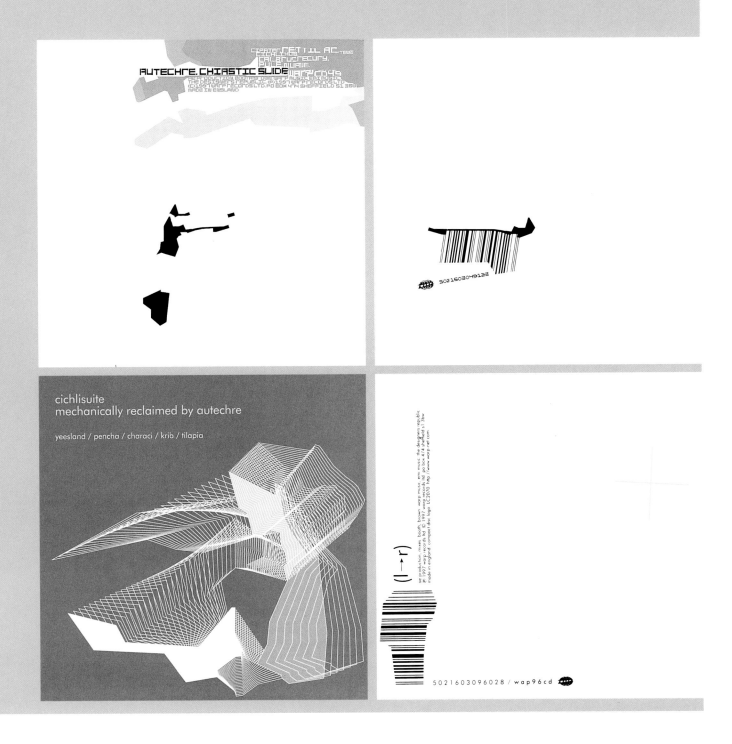

warpcd 66

Autechre
LP5

Black CD jewel case with
embossed name and title.

Design: The Designers Republic
Warp Records
1998

Boards of Canada
Music Has The Right To
Children

CD front and booklet inner spread.

Design: Boards of Canada
Warp Records/Skam Records
1998

boards of canada
music has the right to children

Squarepusher
Music is Rotted One Note

CD front.

Design: Kleber
Warp Records
1998

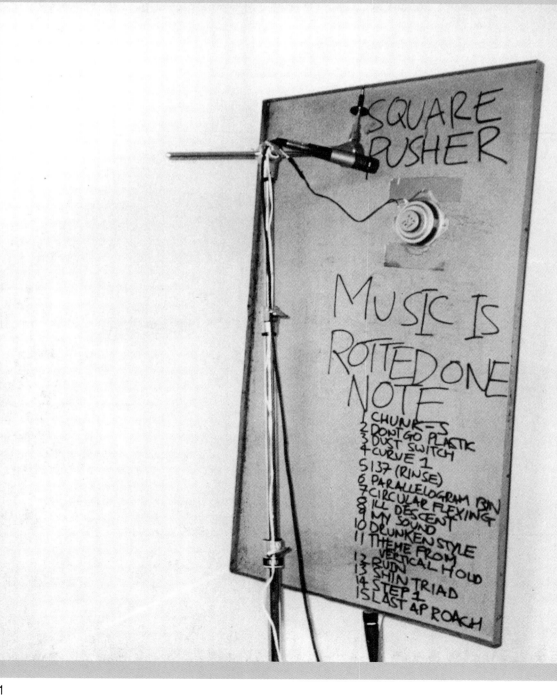

Matmos
Matmos

CD front and 2 hand assembled
inner trays – each one different.

Design: Rex Ray
Photography:
Cliff Hengst/Scott Hewicker
Vague Terrain
1997

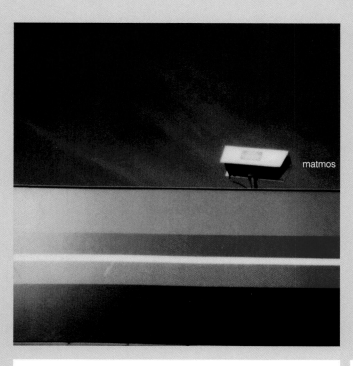

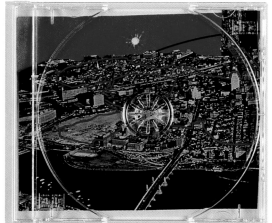

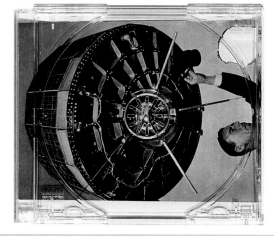

Gomez
Bring It On

CD front. (Opposite) CD booklet detail.

Design: Jonathan Cooke
@ Blue Source
Illustration: Reggie Pedro
Hut Recordings
1998

Gomez
78 Stone Wobble

CD front.

Design: Jonathan Cooke
@ Blue Source
Illustration: Reggie Pedro
Hut Recordings
1998

Gomez
Whippin' Piccadilly

CD front.

Design: Jonathan Cooke
@ Blue Source
Illustration: Reggie Pedro
Hut Recordings
1998

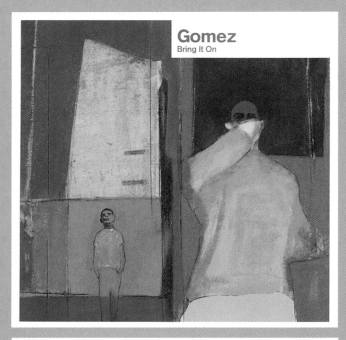

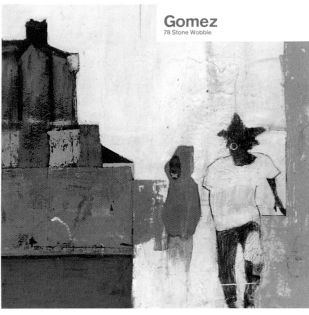

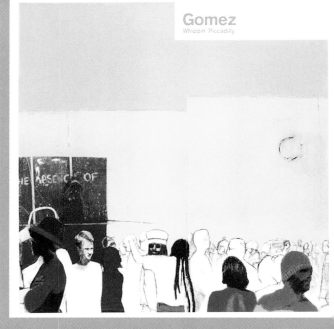

Beatnik Filmstars
In Hospitalable

CD booklet and reverse inner tray.
Design: John Austin & Andrew Jarrett
Merge Records
1998

beatnik filmstars
in hospitalable

beatnik filmstars are andrew jarrett.
jeremy francis. tim rippington. tom adams.
john austin. recorded at vegetables by
granger for dynamic sound. produced by
andrew jarrett and john austin. song 12
guest vocal by ric menck.
talking by phone kids (anon). song 8
sample from 'my pretty rose girl' by reg
harris trumpet trio on superior tone
records. sleeve and songs by
jarrett/austin. copyright control. write to
beatmail. box 788. bristol. bs99 1sf.
england.

beatnik fi

artist	⟹	beatnik filmstars	
title	⟹	inhospitalable ⟵	
songs	1	phone kids phone kids (edit)	
songs⟩	2	hep boys (into krautrock) hep boys (into krautrock)	
	3	artist v star artist v star	
	4	RANSACK the misfits. ransack the misfits	
	5	look up + be AMAZED. look up and be amazed	
	6	WRONG wrong	
	7	FOOTSTANDS footstands	
	8	buffalo bill buffalo bill haircut haircut.	
	9	ATLAS atlas	
	10	NOW IM A MILLIONAIRE now i'm a millionaire	
	11	O n. -16, -3, O 0, minus 16, minus 3, 0	
	12	my incident free life my incident free life	
	13	geiger water deep. geiger water deep	
	14	skiving in MONO skiving in mono	
	15	everything is relative / this is a everything is relative / this is a take take.	
	16	mess mess	
	17	is this is RAD? is this is rad?	
	18	LIFESTYLES OF THE RICH lifestyles of the rich and famous + FAMOUS	
	19	fracture fracture	
	20	phone kids.(complete) phone kids (complete)	

MERGE
RECORDS

beatnik filmstars

in hospitalable

laucd4

laucd5 laucd7

Menswear
I'll Manage Somehow

CD front.

Design: Mark Caylor @ Stylorouge
Illustration: Mark Blamire
Laurel/London
1995

Menswear
Daydreamer

CD front.

Design: Mark Caylor @ Stylorouge
Illustration: Ian Howatson
Laurel/London
1995

Menswear
Sleeping In

CD front.

Design: Mark Caylor @ Stylorouge
Photography: Simon Fowler
Laurel/London
1995

NUD 25S

Geneva
Into The Blue

7" front.

Design: Roger Fawcett Tang @ Struktur
Image by Gerald Van Der Kaap taken
from hover hover 1991 installation
view, Stedelijk Museum, courtesy
Torch Gallery, Amsterdam
Nude
1998

NUD 28CD 1/2

Geneva
Tranquillizer

2 x CD slipcases. Inner wallets visible
through die-cut holes.

Design: Roger Fawcett Tang
@ Struktur
Photography: Toby McFarland Pond
Nude
1998

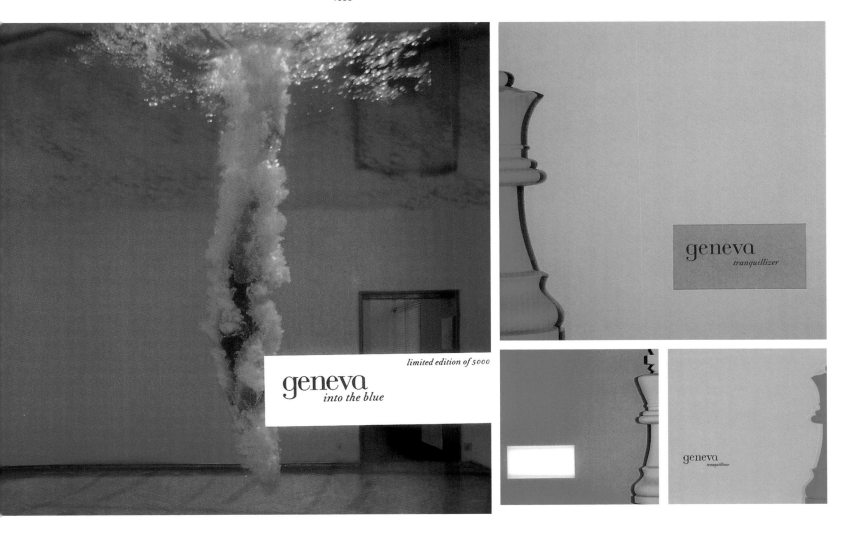

CDS-TUMM 117　CDS-TUMM 171

Bruce Gilbert
Ab Ovo

Bruce Gilbert
In Esse

CD inner and front.

CD inner and front.

Design: Russel Haswell
Mute Records
1996

Design: Russel Haswell
Mute Records
1997

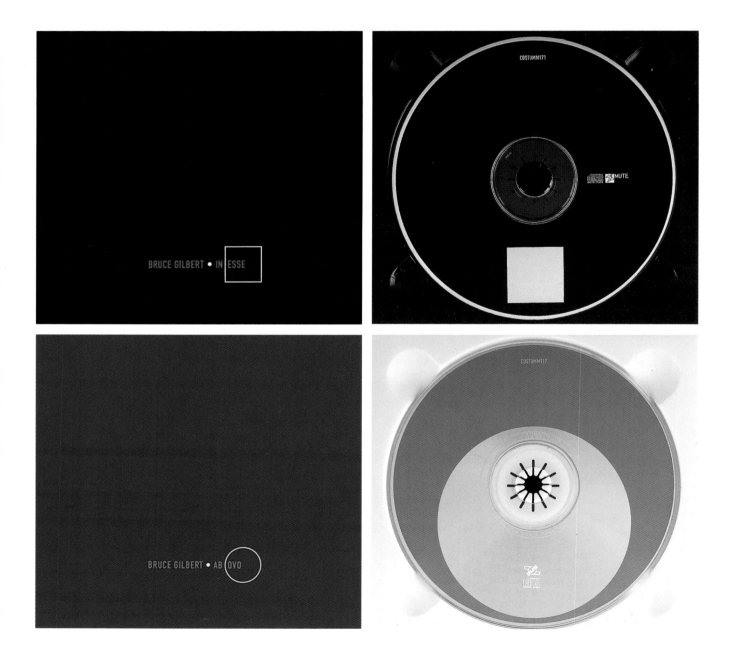

Cinnamon Smith
The Uvver Half

7" front, back and CD inner.

Design: Paul West/Paula Benson
@ Form & hYSTERON pROTERON
Photography:
hYSTERON pROTERON
Mother Records
1998

Cinnamon Smith
The Curates House

CD wallet reverse.

Design: Paul West/Paula Benson
@ Form & hYSTERON pROTERON
Photography:
hYSTERON pROTERON
Mother Records
1998

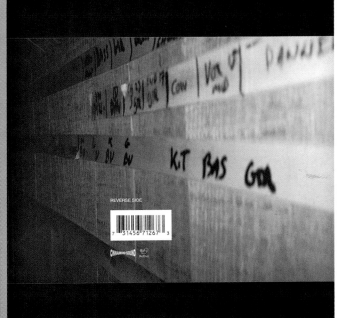

A THE UVVER HALF B GUIDE ME TO BED

CINNAMON SMITH,
THE UVVER HALF.

MUSIC BY CINNAMON SMITH. THE UVVER HALF PRODUCED BY PHIL VINALL.
ENGINEERED AND MIXED BY TEO MILLER. GUIDE ME TO BED PRODUCED
BY CINNAMON SMITH. ENGINEERED BY IAN DAVENPORT. CINNAMON SMITH
ARE MARK SMYTH, GRAHAM MATTINGLEY AND KIERAN BATTLES.
http://www.cinnamonsmith.co.uk · DESIGN BY FORM™ http://www.form.uk.com
& hYSTERON pROTERON. PHOTOGRAPHY BY hYSTERON pROTERON.

CINNAMON·SOUND Mother BIEM/MCPS LC 0309 PY102
MUM 103

Earl Brutus
Tonight You Are
The Special One

CD front and booklet spread.

Art direction and design:
Scott King/Studio 3 Quarters
Cover concept: 'I've Got a
Window Wednesday' by Crash
Photography: Jack Daniels (front)
Jamie Fry (still life)
Island Records
1998

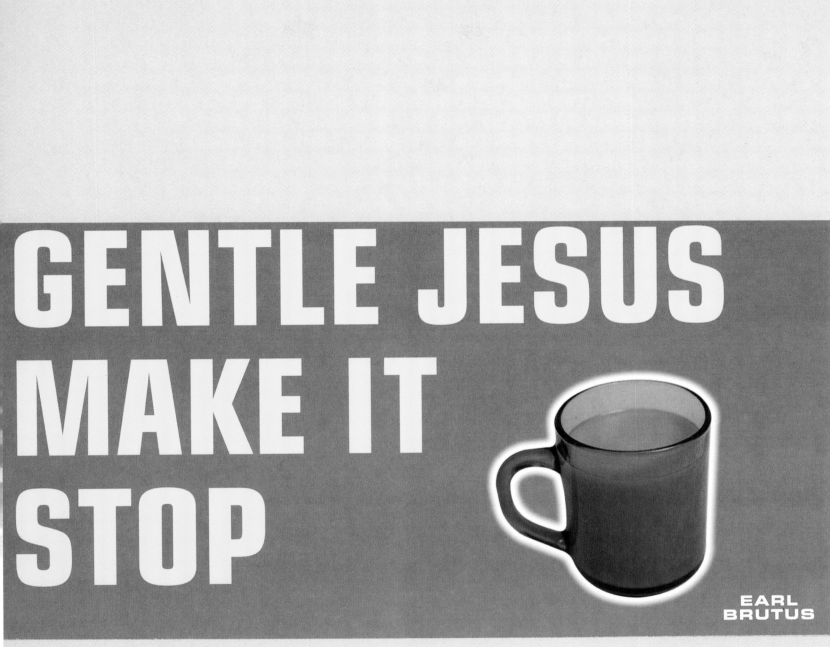

SILEX8

Silex
No. 8 Silex avec le Disque

Illustrated book with 7" disc.

Design: Mr & Mrs Silex
Silex
1998

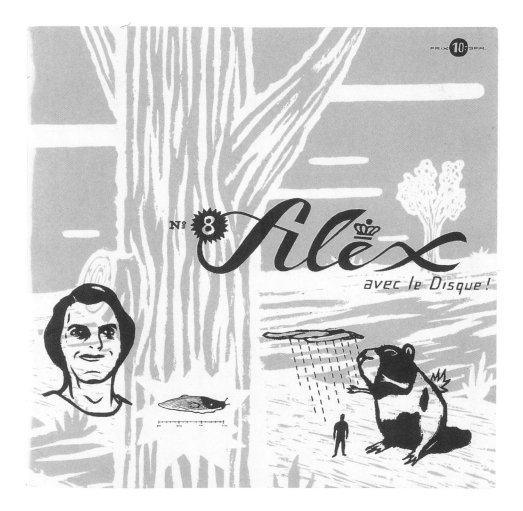

Pronoise
Pronoise live in an
apartment, Zurich

Cassette packaging x 2.

Design: Karla K & Elektrosmog
Photography: Isabel Truuiger
Sun-Tic Records
1997

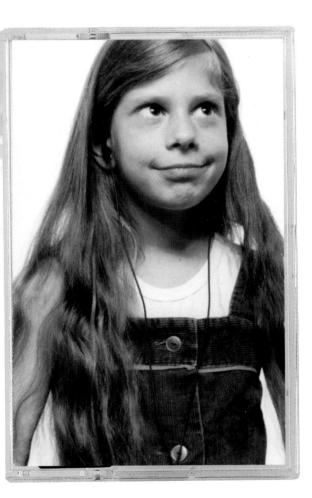

Barry Adamson
What It Means

CD promo package.

Design and photography: Intro
Mute Records
1998

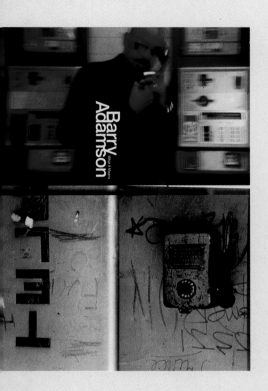

Nick Wood
Sound Virus

CD outer and circular booklet spread.

Design: North
Syn Production
1998

Nick Wood Sound Virus SYC–0001

**Nick Wood
Sound Virus**

1
Cupid's a Hitman (Remix)
Music composed by Nick Wood
Lyrics written by Nick Souter
Vocals: Eden
Original song from the Mario Van
Peebles' film 'Love Kills'
Remixed for PARCO TVCM 'Red'

2
Tokyo Muscle
Original song from the Bruce
Osborne film 'Tokyo Muscle'

3
Hello Old Friend
Produced by Nick Wood and
Michael Becker
Music & lyrics by Dr. John and
Composers' Workshop
Piano & vocals: Dr. John
Music arranged by Ronnie Cuber
Original song from the LARK
TVCM 'Reunion'

4
Do You Love
Music composed by Nick Wood
Lyrics by and Michael Becker
Vocals: Angela McCluskey
Trumpet: Jon Hassell
Original song from the Virginia
Slim TVCM 'Kinishinai'

5
Confined to Ice
Trumpet: Jon Hassell
Percussion: Yas-kaz
Guitar: Tomohiko Kira
Original song from the Pioneer
LDC Picture 'Crystal Water'

6
Graceful
Vocals: Yoko Ueno
Programmed and mixed by
Nick James
Original song from the Pioneer
LDC Picture 'Crystal Water'

7
Sound Virus
Vocals: Nick Wood and Yoko
Ueno
Synth sounds: Nick James
Sound design: Shawn Ellis and
Hideaki Katayanagi
Original song from Shiseido
'Breath Garden'

8
Sex Police
Guitars: Tomohiko Kira
Trumpet: Eric Miyashiro
Flute and barriton sax: Ronnie
Cuber
Mixed by Nagie
Original musical idea from
Shiseido 'Annessa'

9
Johnny Walker
Guitars: Chuei Yoshikawa
original song from XXXXXXXX

10
New Track
Original song from XXXXXXXX

1
Cupid's a Hitman (Remix)
Original song from the
Mario Van Peebles' film
'Love Kills' remixed for
the Parco TVCM 'Red'

2
Tokyo Muscle
Original song from the
Bruce Osborne film
'Tokyo Muscle'

3
Hello Old Friend
Original song from the
LARK TVCM 'Reunion'

4
Do You Love
Original song from the
Virginia Slim TVCM
'Kinishinai'

5
Confined To Ice
Original song from the
Pioneer LDC Picture
'Crystal Water'

6
Graceful
Original song from the
Pioneer LDC Picture
'Crystal Water'

7
Sound Virus
Original song from
Shiseido 'Breath Garden'

8
Sex Police
Original music idea
from Shiseido 'Annessa'

9
Johnny Walker
Original song from
XXXXXXXXXX

10
Original song from
XXXXXXXXXXX

syn

Rojak

JASRAC

Stereo
℗©1998 Syn Production
Made in Japan
¥ 2,500

compact disc
DIGITAL AUDIO

The Mad Dog Reflex
The Kickback [A1]

The Harder it
Comes [A2]

Skycutter's
Kickback Remix [A3]

The Mad Dog
Reflex
The Kickback [A1]

The Harder it
Comes [A2]

Skycutter's
Kickback Remix [A3]

A1 Van der Flult/Damjan
Engineered by Steve Dub at Dada Studios
Vocal trip by Da Chill
A2 Van der Flult/Damjan
Engineered by Ed Solo at S.O.U.R.
Drums by Dan
A3 Van der Flult/Damjan
Additional production and mix
by Skycutter
All tracks copyright control

The Mad Dog Reflex
The Harder It Comes/
The Kickback

12" front, back and labels.

Design: North
Kahuna Cuts
1998

KCuts
002

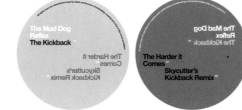

PL12
BONG
29

LMUTE
L1

MUTE
L5

PCD
MUTE
L5

Depeche Mode
Only When I Lose Myself

Depeche Mode
The Singles 81>95

Depeche Mode
The Singles 86>98

Depeche Mode
The Remixes 86>98

Promo 12" sleeve (top left).

Art direction: Mat Cook @ Intro
Photography: Rick Guest
Mute
1998

12" sleeve reverse (bottom left).

Art direction: Mat Cook @ Intro
Photography: Rick Guest
Mute
1998

12" sleeve from box set (top right).

Art direction: Mat Cook @ Intro
Photography: Rick Guest
Mute
1998

CD booklet page (bottom right).

Art direction: Mat Cook @ Intro
Photography: Rick Guest
Mute
1998

NoMu
57LP

Luke Slater
Freek Funk

12" album front.

Art direction: House @ Intro
Photography: Spiros Politis
Mute Records
1997

12
NoMu
56

Luke Slater
Freek Funk

12" single front.

Art direction: House @ Intro
Photography: Spiros Politis
Mute Records
1997

12
NoMu
62

Luke Slater
Love (remix)

12" single front.

Art direction: House @ Intro
Photography: Spiros Politis
Mute Records
1997

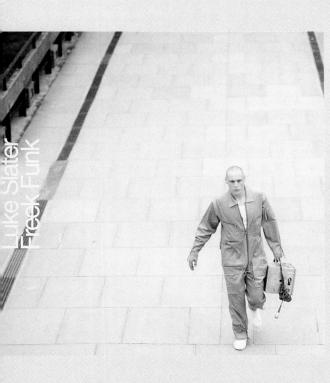

Luke Slater
Freek Funk

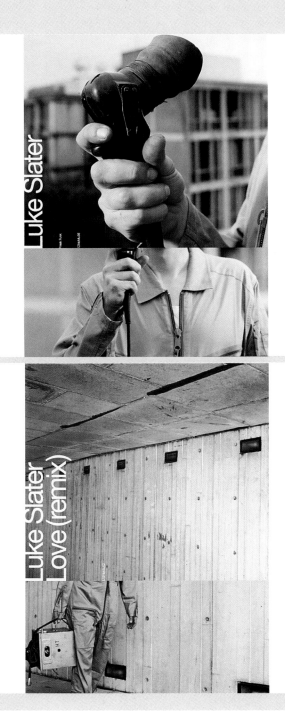

Luke Slater
Love (remix)

314 537
154-2

Bill Evans
The Complete Bill Evans

Metal box incorporating book and
18 CDs in metal holder.

Art direction and design:
Patricia Lie @ Verve
Verve
1997

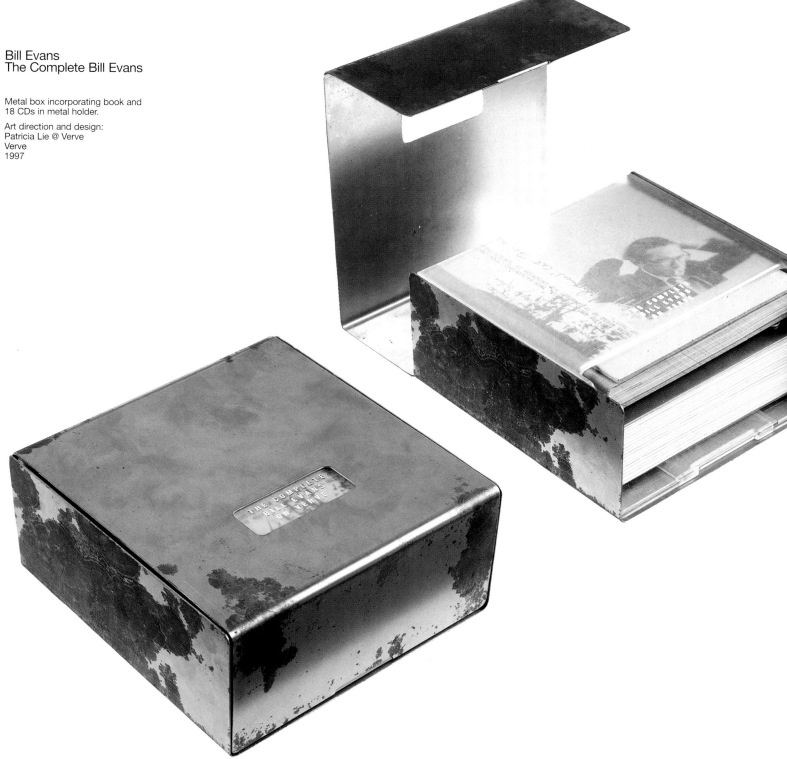

BY JOSEPH LAREDO

Eddie Gomez. Photograph by Giuseppe Pino

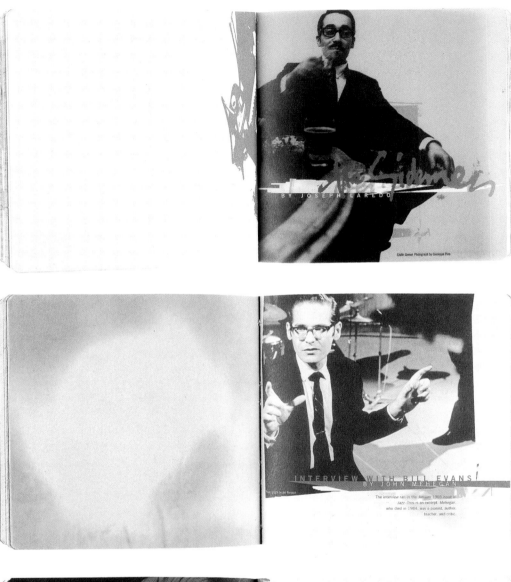

INTERVIEW WITH BILL EVANS
BY JOHN MEHEGAN

The interview ran in the January 1965 issue of
Jazz Trio is an excerpt. Mehegan,
who died in 1984, was a pianist, author,
teacher, and critic.

Photograph by Jan Persson

Evans's approach to the piano — in which neither right-hand melodies nor left-hand rhythms predominated, but rather the two engaged each other in a musical conversation — extended beyond the keyboard. It became the foundation for his philosophy of the piano too, and that philosophy, along with his extraordinary lyricism, remains the most enduring aspect of his music.

Until Evans's time, piano trios existed primarily to support the pianist, forming a rhythmic framework for the keyboard solos. Evans, however, wanted a trio in which no one element dominated constantly, in which each player could push the music in the direction of his choice at any given time. Evans's stated objective was to achieve a musical unit that could "grow in the direction of simultaneous improvisation, rather than just one guy blowing followed by another guy blowing". He then asked, "If the bass player has a solo that he wants to answer, why should I be just keep playing a 4/4 background?" He wanted a group that matched his own demands of himself: to "change directions at any moment" in the creation of music, that he also wanted a trio that would express his lyricism. "Especially, I want my work — and the trio if possible — to sing."

Given his own subtle iconoclasm, Evans could hardly have missed hearing it in other artists, no matter how different a form it might take. In the early Sixties, he wrote the brief liner note for an album by Thelonious Monk, the long-misunderstood genius who had previously carved a striking keyboard style of his own:

"This man knows exactly what he is doing in a theoretical way — organized, more than likely, in a personal terminology, but strongly organized nevertheless. We can be further grateful to him for combining aptitude, insight, drive, compassion, fantasy, and whatever else makes the 'total' artist, and we should also be grateful for such direct speech in an age of insurmountable conformist pressures."

Evans also used Monk as an example of how "any man can be great if he works true to his talents, neither over- nor underestimating them and, most important, functions within his limitations". It doesn't take any great leap of analysis to imagine Evans's words applying to Evans himself.

Photograph by Chuck Stewart

halo seven

halo eight halo ten

Nine Inch Nails
March of the Pigs

CD front.

Design: Gary Talpas & Russell Mills
Photography: Andrew Morris
Paintings and assemblages by
Russell Mills
Nothing Records
1994

Nine Inch Nails
The Downward Spiral

CD slipcase. CD front (opposite).

Design: Gary Talpas & Russell Mills
Photography: Andrew Morris
Paintings and assemblages by
Russell Mills
Nothing Records
1994

Nine Inch Nails
Further Down The Spiral

CD front.

Design: Gary Talpas & Russell Mills
(Images)
Photography: Andrew Morris
Paintings and assemblages by
Russell Mills
Nothing Records
1995

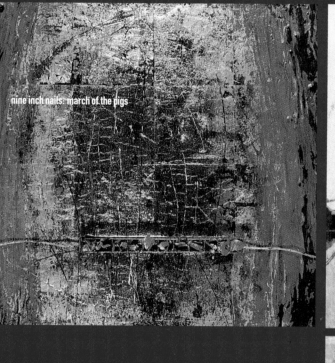

nine inch nails: march of the pigs

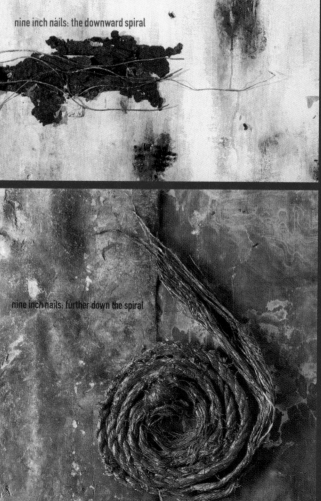

nine inch nails: the downward spiral

nine inch nails: further down the spiral

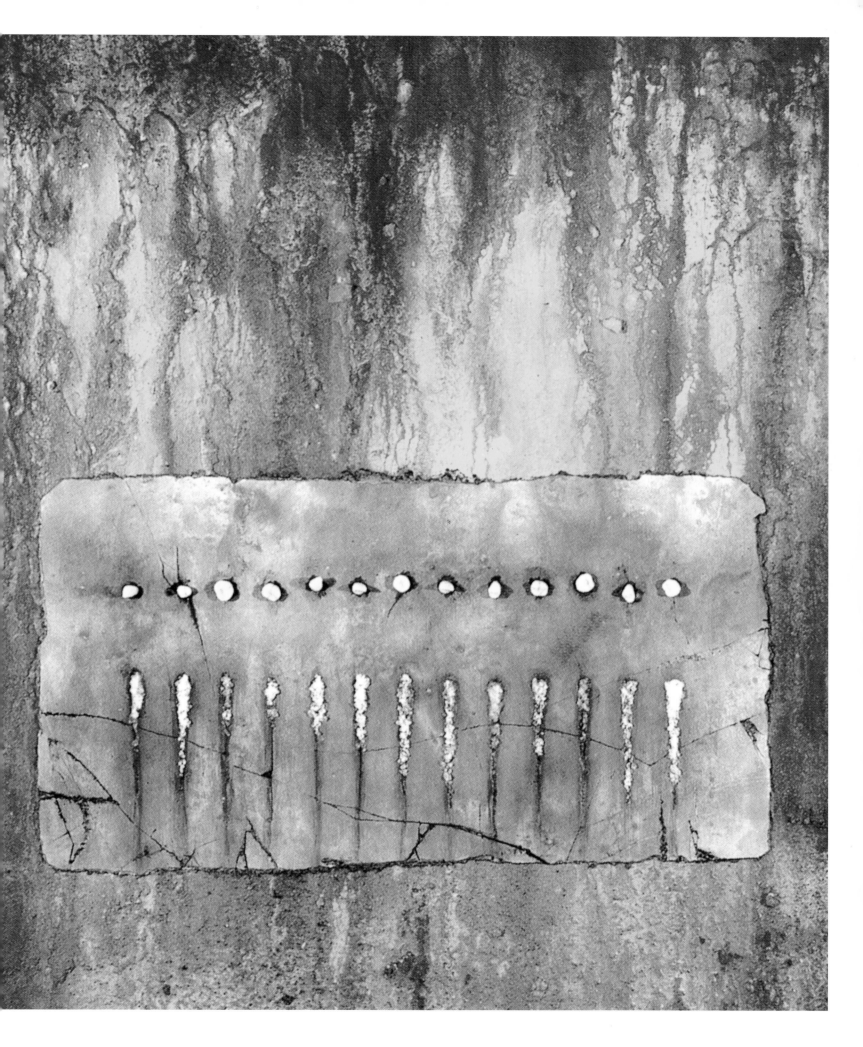

DSRM1

David Sylvian and
Russell Mills
Ember Glance

Spread from book accompanying CD.

Design: Russell Mills &
David Coppenhall @ mc^2
Photography: The Douglas Brothers,
Masataka Nakano
Virgin Records
1991

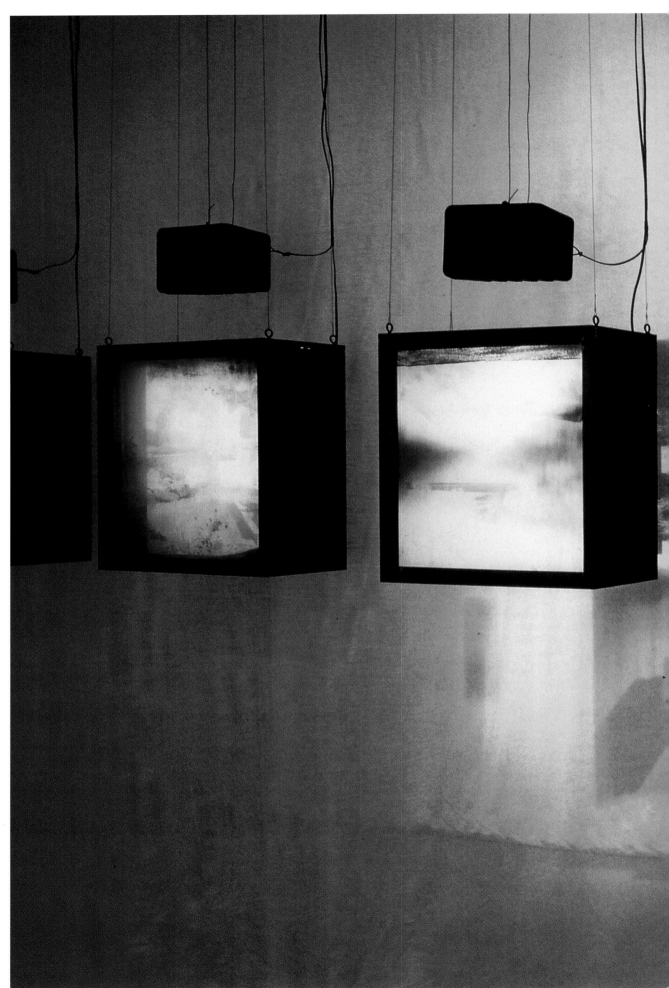

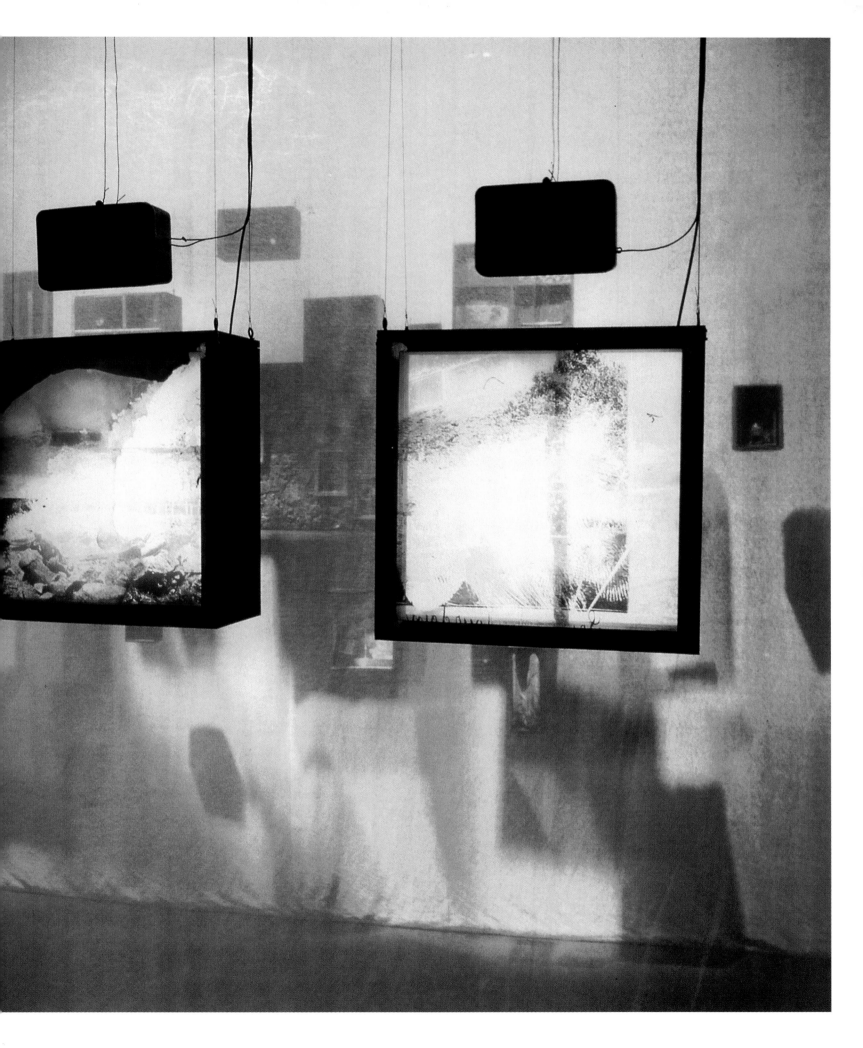

The Heartists
Belo Horizonti

CD promo wallet.

Design: Paul West/Paula Benson
@ Form
Photography: Form
Original VC logo:
Michael Nash Associates
Virgin Records
1997

D*Note
Waiting Hopefully

CD promo wallet.

Design: Paul West/Paula Benson
@ Form
Photography: Form
Original VC logo:
Michael Nash Associates
Virgin Records
1997

Sunship
Heaven

CD wallet.

Design: Tom Hingston
@ Tom Hingston Studio
Filter/Dorado Records

Test Recordings
House bag

Regal
House bag

12" sleeve.

Design: Jon Black @ Magnet
Test Recordings
1998

12" sleeve.

Design: Tony Hung @ Stylorouge
Illustration supplied by Barnabys
Regal Recordings
1998

'... while as Merzbow, Masami Akita, who recorded 24 albums in 1969 alone, endlessly refines a single idea of aural discomfort, and is reputed to have released a CD in a limited edition of one, sealed within the in-car stereo of a new Mercedes.'

Stewert Lee, article in
The Sunday Times November 1998

[Disc]redits

An Intro Book Project

Editor: Adrian Shaughnessy
Design: Julian House
Additional design: David Smith &
Adrian Talbot
Business affairs: Katy Richardson
Administration: Annabel Price

Photography: Ian Jackson
Pages 30 and 31: Lee Funnell
Pages 4, 5, 10 and 15: Julian House
Additional photography: Mikko Eley

The original idea to produce a book on contemporary music graphics was Lewis Blackwell's: thanks to him.

Thanks to those within the design community who gave help, advice and – most importantly – samples of work. Those deserving of special mention include: Paul West and Paula Benson at Form (London), Rob O'Connor at Stylorouge (London), Mason Wells at North (London), Paul Winter at Lab Projects (London), Cally Calloman at Antar (Suffolk), Chris Foges at Graphics International (London), Roger Fawcett Tang at Struktur (London), Stefan Sagmeister at Sagmeister Inc. (New York), Tom Hingston (London), Gary Saint Clair and David Calderley at V2 (USA), Ben Drury at MoWax (London), Vaughan Oliver at v23 (London), Val Hindermann (Zurich), Seb at Blue Source (London), Chika Azuma at Verve /Antilles (New York), Marie Josephe at A.P.C. (Paris) and special thanks to Russell Mills (Cumbria).

Within the record industry the following people gave invaluable assistance and advice: Rob Mitchell at Warp (Sheffield), Mark Sattler, Dieter Rehm and Manfred Eicher at ECM (Germany), John L. Walters at Unknown Public (London), Andy Townsend at Nude (London), Iain Scott at Triple Earth (London), Quinton Scott (London), Seth Hodder, Paul Taylor and Daniel Miller at Mute (Harrow Road) Chris Hendrie at Island (London and Glasgow), Jan De Mars and Geert Meets at R&S (Gent), Bettina at Thrill Jockey (Chicago), Kate Neilsen, Yvette Lacey, Tim Strickland at The National Centre of Popular Music (Sheffield), Mark Conway at Higher Ground (London), Nathalie Noënnec at Source (Paris), Martin Pike at Duophonic (London), Mark Fischer at SKiN GRAFT (Chicago), Sarah Withers and Andrew Mansi.

Within Intro thanks are due to Mat Cook (for creative interference), Rachael Hamilton, Michael Williams and Monica Clements.

Thanks to Laurence, Jo, Laura and Felicity at Laurence King.

Dedicated to Lynda, Ed, Alice and Moll.

The work selected for inclusion in *Sampler* is the choice of the book's writer and designer. Most of the entries were chosen from submissions by designers and record companies who responded to an invitation to submit work of their own choice. Most responded with enthusiasm and encouragement and to these individuals we extend our warmest thanks; a book like this is only as good as its contributors. A small number of those approached declined to take part.

The remaining entries were chosen by the writer and the designer from their own collections, or found during long hours spent hanging about in record shops. The following shops proved helpful in locating hidden treasure: Rough Trade, Covent Garden, London; Tower Records, Sunset Boulevard, Los Angeles; Selectadisc, Berwick Street, London.

All record covers referred to in the text, and dated prior to 1990, are the original vinyl LP versions. Many CD conversions of classic album covers are extremely inept and render proper evaluation impossible.

All label names and release dates are taken from versions in the possession of the writer, or from printed sources. Labels and release dates may vary from country to country.

Designers engaged in sleeve design in the UK may be interested in joining AMID (Association of Music Industry Designers). Membership details can be obtained by writing to: Paul West or Paula Benson, AMID, c/o Form, 3 Long Yard, London WC1N 3LV.

Bibliography

A Year with Swollen Appendices Brian Eno
(Faber and Faber, 1996)
The Album Cover Art of Soundtracks Jastfelder/Kassel
(Little, Brown, 1997)
Album Covers from the Vinyl Junkyard
(Booth-Clibborn Editions, 1997)
Blimey Matthew Collings (21, 1997)
Broken Music: Artists' Recordworks Block/Glasmeier
(Catalogue, 1989)
David Stone Martin, Jazz Graphics Manek Daver
(Graphic Sha, 1991)
Design Without Boundaries Rick Poynor
(Booth-Clibborn Editions, 1998)
ECM Sleeves of Desire: A Cover Story
(Lars Muller Publishers, 1996)
England's Dreaming Jon Savage (St. Martins Press 1992)
From Joy Division to New Order. The Factory Story
Mick Middles (Virgin, 1996)
The Graphic Language of Neville Brody Jon Wozencroft
(Thames and Hudson, 1988)
Moving Out Robert Frank (Scalo, 1994)
Ocean of Sound David Toop (Serpents Tail, 1995)
1000 Record Covers Michael Ochs (Taschen, 1996)
Pop Art. A Continuing History Marco Livingstone
(Thames and Hudson, 1990)
Rap Attack 2 David Toop (Serpents Tail, 1991)
Revolution in the Head Iain MacDonald
(Fourth Estate, 1994)
The Sixties Art Scene in London David Mellor
(Phaidon, 1993)
Support the Revolution Wallace Berman
(Institute of Contemporary Art/Amsterdam, 1992)
Surfing the Zeitgeist Gilbert Adair (Faber and Faber, 1997)
*Time Travel: From the Sex Pistols to Nirvana: Pop, Media
and Sexuality* Jon Savage (Vintage, 1997)
Vital Signs Ian Penman (Serpents Tail, 1998)
Waiting for the Sun Barney Hoskyns (Bloomsbury, 1996)
With a Little Help from my Friends George Martin
(Little, Brown, 1994)

Articles

Claire Catterall, 'New Graphic Realism' *Blueprint*
(No. 155 November 1998)
Michael Johnson, article on Peter Saville,
'Back on the Beat' *Design Week* (15 May 1998)
Rick Poynor, interview with Peter Saville *Eye* (No.17 Vol. 5)
Rick Poynor, profile of Mark Farrow *Eye* (No.24 Vol. 6)
James Roberts, 'The Album Covers of Hipgnosis' *frieze*
(Issue 37)
Adrian Shaughnessy, article on contemporary sleeve
design *Creative Review* (December 1997)
Adrian Shaughnessy, article on ECM *Eye* (No.16 Vol. 4)
Susan Squire, article on Neon Park *LA Magazine*
(September 1980)
Julia Thrift, article on Barney Bubbles *Eye* (No.6 Vol. 2)
Alice Twemlow, profile and interview with Stefan
Sagmeister *Graphics International* (Issue 52)